BECCLES

THROUGH TIME

Dr Barry Darch

Photographs by Alan Wheeler

AMBERLEY

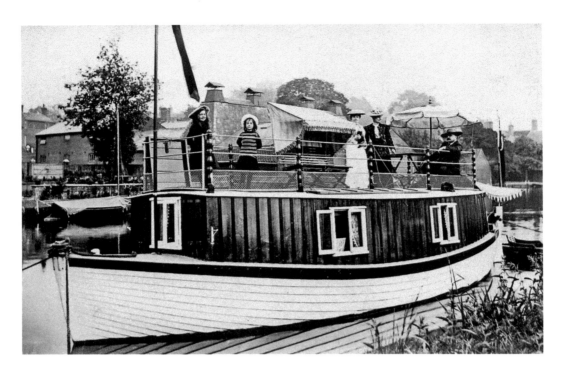

On the Waveney

As well as for trade the Waveney has provided many opportunities for recreation, as this image of leisurely boating from over a century ago demonstrates. Granville Baker, a historian of Beccles, wrote, 'River and town have lived and worked together, for so many ages, that their lives are a joint affair, completely interwoven one with the other.'

First published 2018

Amberley Publishing
The Hill, Stroud, Gloucestershire, GL5 4EP
www.amberley-books.com

Copyright © Dr Barry Darch, 2018

The right of Dr Barry Darch to be identified as the Author of this work has been asserted in accordance with the Copyrights, Designs and Patents Act 1988.

ISBN 978 1 4456 6512 2 (print)
ISBN 978 1 4456 6513 9 (ebook)

British Library Cataloguing in Publication Data.
A catalogue record for this book is available from the British Library.

Origination by Amberley Publishing.
Printed in Great Britain.

Introduction

Beccles has a documented history of over a thousand years, but archaeological evidence has been found of much earlier occupation, as illustrated by stakes marking out a trackway across the marshes, put in place in the first century BC. One of these remarkably well-preserved stakes has found a home in Beccles and District Museum. Roman artefacts have been discovered within the parish, including part of a flagon found at Petit Couronne Way. The teenage King Edwy, who reigned 955–959, gave Beccles to the monastery of Bury St Edmunds. Regarded as a poor ruler, he was nevertheless generous in his granting of land – perhaps as an atonement for his wayward ways!

By the time of the Domesday Book in 1086 Beccles was established as a trading community. If you had visited Beccles market then, you might have admired the twin towers of St Peter's Church, built in the late Saxon or early Norman periods, but the odour of the plentiful herrings on sale might have shortened your gazing. In the Middle Ages Beccles developed to be a significant market town, which it remains to this day. For much of its history it was the third town of Suffolk, after Ipswich and Bury St Edmunds.

A disastrous conflagration in 1586, followed by three fires in the following century, caused much damage, so little remains of medieval Beccles except its church of St Michael the Archangel and the 'gate' suffix of its ancient street names. This 'gate' owes nothing to the word in its main modern sense but is a Norse word for street, which is also found in York.

In the eighteenth century the prosperity of Beccles was shown by the building of substantial houses, many of which remain in Ballygate and Northgate. T. K. Cromwell in his *Excursions in the County of Suffolk* (1819) described Beccles as 'a large well-built town ... remarkable for longevity, the air being very salubrious'. The air quality dipped in the second half of the nineteenth century as Beccles became more industrial, particularly through the growth of the printing business of Clowes. The town grew significantly at this time, outstripping its neighbour Bungay, with which it maintains a friendly rivalry to this day, expressed in sporting and other competitions.

In the twentieth century the housing stock improved significantly. Several of the old Yards towards the north of the town were cleared; local authority estates were built after the Second World War and private housing more recently. But some buildings that would perhaps be preserved today have been demolished, especially for road widening.

Today Beccles is known for its community spirit, reflected in a vast array of clubs and organisations. Although most of its manufacturing is now on the edge of the town or just beyond it, it is still very much a centre of commercial activity, with traditional and modern shops, a Friday street market and events such as antiques fairs and a food festival. Beccles also takes pride in its past, as reflected in its civic society (The Beccles Society), annual Charter Weekend, museum, historical society and several other history groups. The town also has a proud tradition of education, of both children and adults.

When I came to Beccles in 1990 I did not know that it was going to be my 'forever home on earth', but its strength of community, amenities, fine views and fascinating history make it very hard for its incomers to leave. As a keen family historian, with no apparent links to Beccles, it has been interesting to discover that my great-grandmother, who in 1881, aged fifteen, was working as a 'copper mine girl' in Cornwall, was descended from the Ros or Roos family, some of whom lived in Beccles in the Middle Ages. As members of the Beccles U3A Family History Group know well, genealogy is full of surprises and we sometimes return circuitously to our roots.

The research for this book has built on my MA dissertation (The Open University), completed earlier this year, on local adult learning 1825–75. I have also drawn on what I discovered as a

member of a U3A group which studied the history of Beccles Public Hall and which published its findings in a booklet in 2017. But more than to my own studies, this publication is indebted to generations of Beccles collectors of history, whose contribution is acknowledged at the end of the book, together with other acknowledgements and thanks.

Unless otherwise indicated, the most recent photographs have been taken by Alan Wheeler, curator of Beccles and District Museum, to whom I am very grateful for manifold help in photography and other matters. Historic images have been drawn mainly from the museum.

I dedicate this book to my wife, Faith, who has a much stronger Suffolk heritage than mine and who has supported my research generously with her time and forbearance.

Barry Darch,
Beccles, 2018

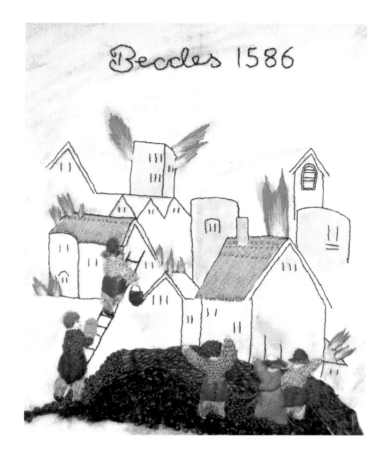

Beccles 1586

Continuing to Inspire...

Images from the town's past often inspire. The exhibition 'Threading Through Time' by members of the Waveney branch of the Embroiderers' Guild, at Beccles and District Museum in 2018, included Jenny Bosanko's scene of the devastating fire of 1586, based on a contemporary woodcut. A Beccles farthing depicting the gaol and pound, itself based on the town seal, inspired Pamela Harrison. Over the years there have been many drawings of the seal – with a variety of impounded animals, according to the artist's taste. No llamas, yet, but Percy the Beccles peacock is a possibility!

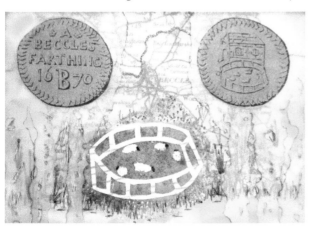

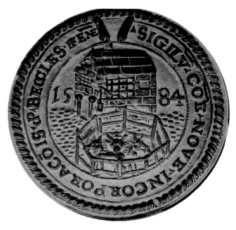

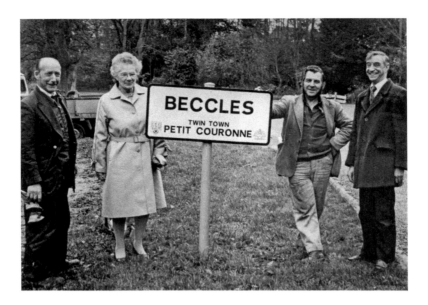

Beccles' Twinning Signage

Beccles was officially twinned with Petit-Couronne in 1978, and since then many exchanges have taken place. Catherine Adam, mayor in 1995–96, stands on the left and Noel Neal, chairman of Beccles Twinning Association, on the far right. Today's equivalents are Mayor Elfrede Brambley-Crawshaw beside the sign on the left (with Town Clerk Claire Boyne) and chairman Michelle Golding on the right (with Michael Graveling, the town's 'Mr Tidy'). Beccles became a Fairtrade Town in 2008 and is pleased to display this also. (Photos: Leslie Freeman; Barry Darch)

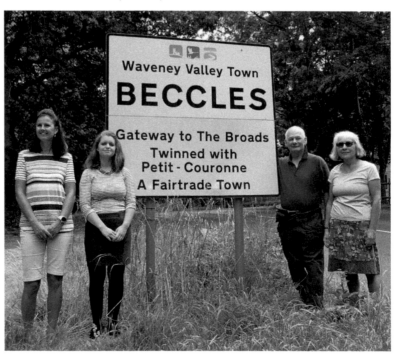

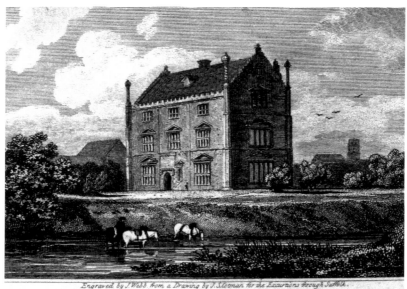

Engraved by J.Webb. from a Drawing by J.S.Cotman for the Excursions through Suffolk.

ROSE HALL, BARSHAM.

SUFFOLK.

Pub.ª Aug.ª 1818. by Longman & Cª Paternoster Row.

Roos Hall

Roos Hall was built in 1583 by Thomas Colby. J. Webb's engraving (from a drawing by J. S. Cotman) appeared in T. K. Cromwell's *Excursions in the County of Suffolk* (1819). It shows what could have been the remains of the moat of the earlier medieval hall of the de Ros family. A significant part of Beccles was once part of 'the manor of Rosehall'. Older Becclesians may remember from their childhoods the fun of a carnival in the hall's grounds. (Engraving: Rix Collection; photo: Alan Ayers)

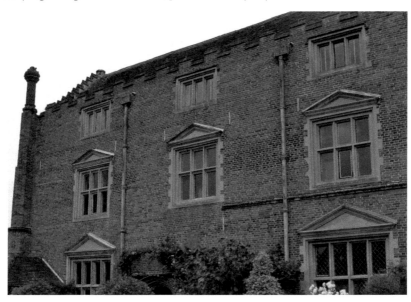

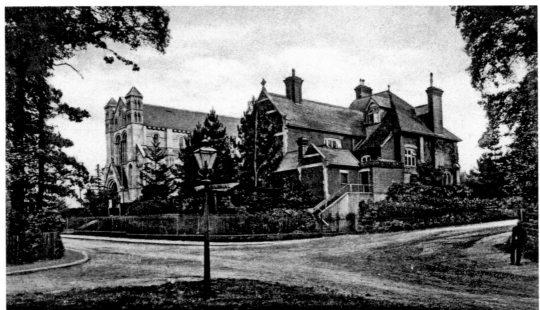

St. Benets Minster & Priory, Beccles. 7459 The "Wyndham" Series

St Benet's Minster and Priory, c. 1903
The priory on the right, originally built for a community of monks, became the main school building when the idea of the community was abandoned. The tower had not been erected when the photograph was taken. The church was completed in 1908, the architect being F. E. Banham, who conveniently lived nearby in Grange Road. The town sign, imagining Elizabeth I presenting the charter of 1584, has replaced the early illuminated direction sign. (Photo: Barry Darch)

The War Memorial

The War Memorial was unveiled in October 1921. Shortly afterwards it was decided to provide a hedge and iron fencing as a protection from children. The current openness of the memorial suggests that today's youngsters have better things to do. The War Memorial Hospital was constructed to the south, opening in 1924. The much-valued medical facilities on the site now include a health centre.

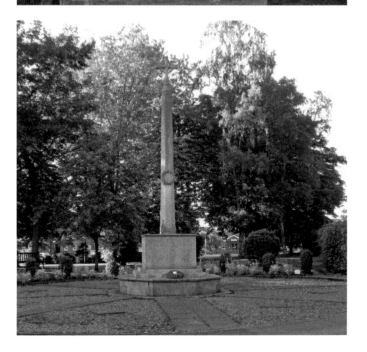

BECCLES WAR MEMORIAL

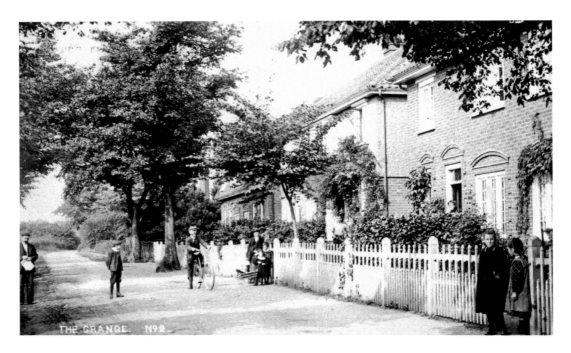

THE GRANGE. No. 2.

South Road

This road was still known as Bullock's Lane at the beginning of the last century when the picture was taken. The Bullock family ran a post mill in the lower part of the road from 1804 until 1876. Near the middle of the picture (above the cyclist) a slender brick water tower can just be seen, later replaced by today's bulkier concrete structure. (Photo: Barry Darch)

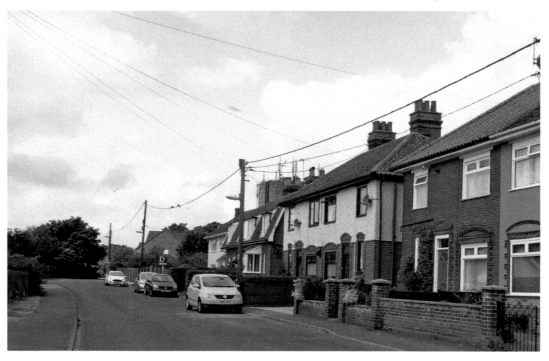

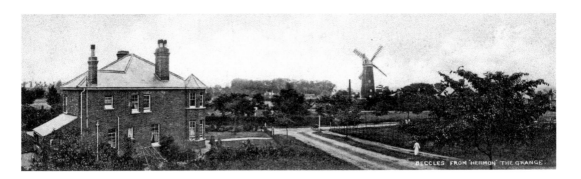

From Waveney Road, Looking North

The house in the foreground (left) was one of the first to be built on the Grange Estate in the 1890s. The mill in the background, known as Hadingham's or Paramount Mill, was demolished in 1923. It had been enlarged to eight floors in the 1840s and was 85 feet high. The house of the miller survives in Priory Road. (Photo: Barry Darch)

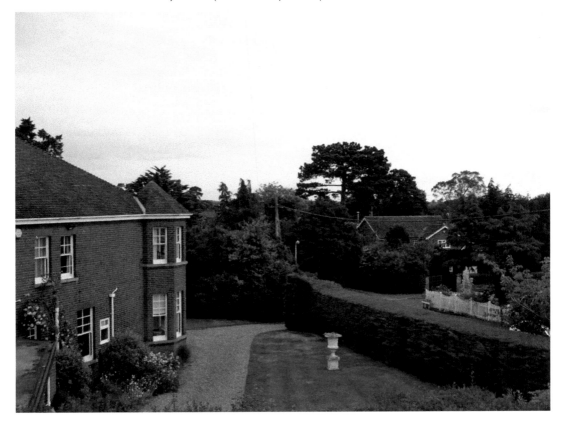

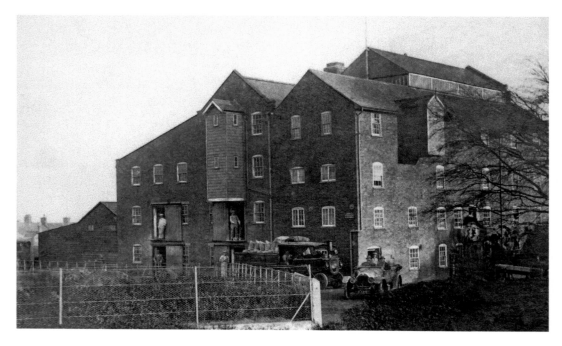

Castle Mill, St George's Road, c. 1925

In 1879 the top of the tower mill, erected here in 1820, broke off in a storm, and the remains were given the appearance of a castle. A steam mill was erected alongside. The tower was dismantled in 1899 and new buildings constructed. In 1925 the drifting airship R33 narrowly missed the mill, having broken loose from its moorings in Norfolk. The mill shut in 1975, replaced by Beech Tree Close, named after the substantial tree that had stood in front of the miller's house.

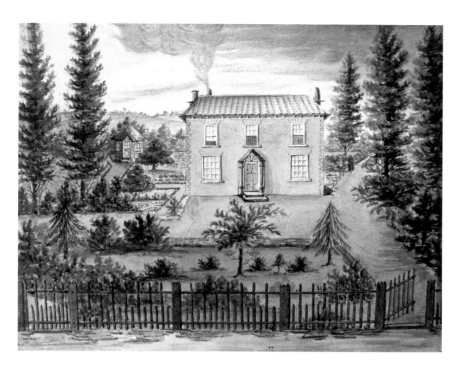

The Larches, London Road

Isaac Sloper was the minister of the Independent Church in Hungate. He purchased the house, built a decade before, in 1803 for £500 – a huge sum – but it had bigger grounds then than now. Later the house was occupied by Read Crisp who founded the first Beccles newspaper in 1857. Sloper added the semicircular south end, and the bow windows were installed in the Victorian period. (Painting: Rix Collection)

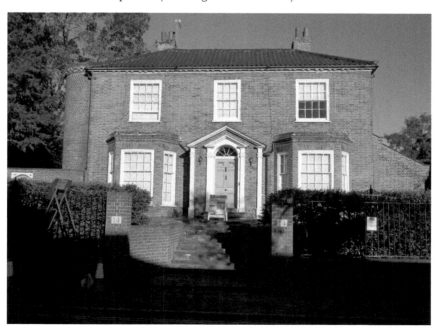

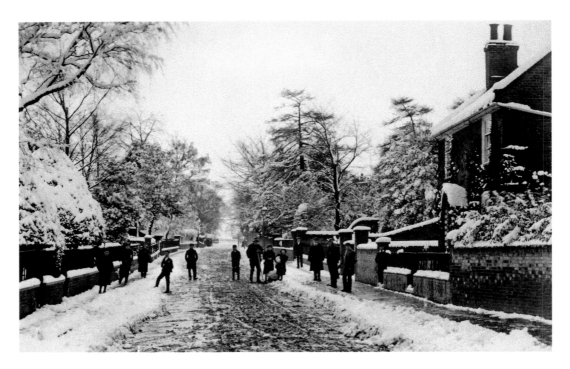

London Road, Looking South

When this photograph was taken in March 1899, the house on the right was occupied by the Buckenham family, who seem to have kept cows on the 3-acre meadow attached. Heavy snow still reduces traffic in London Road, but the southern relief road, due to open in autumn 2018, may also have the same effect. (Photo: Barry Darch)

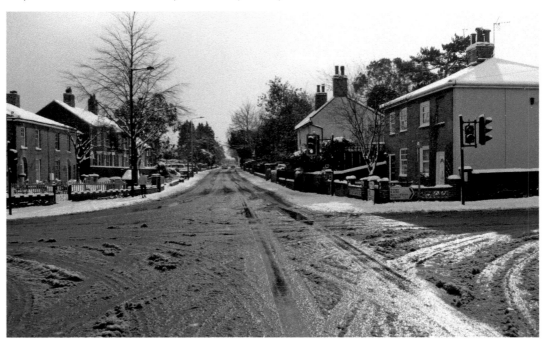

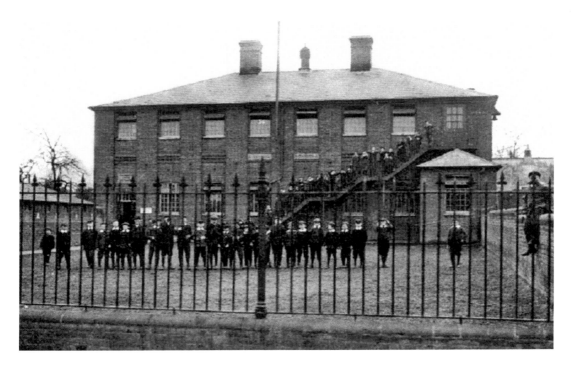

The Council School, Peddars Lane

What is now Durrants Auction Rooms was built as a silk factory in 1857, most of the employees being young women and girls as young as eleven. The factory closed after around a decade and was converted into a school, which educated several generations of Beccles children. The new buildings of the adjacent Albert Pye Primary School, named after a former mayor of Beccles, opened in 1968.

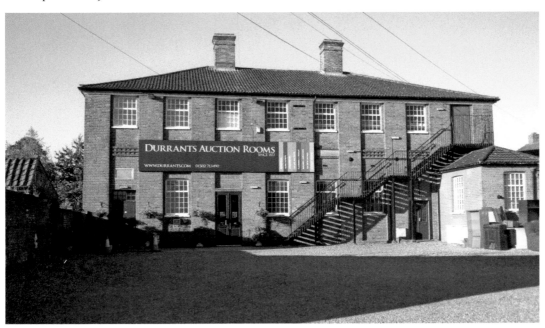

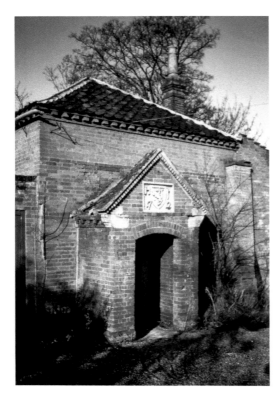

The Fauconberge School, Ballygate
The structure behind the arch was the schoolroom of the Fauconberge School. The room was demolished in 1983, although the school had left the premises in 1906. The institution's endowment was transferred to the Fauconberge Educational Foundation, which still supports the learning of local children. In the Middle Ages the site accommodated the leper hospital of St Mary. Today it provides flats. (Photos: Rosemary Hewlett; Barry Darch)

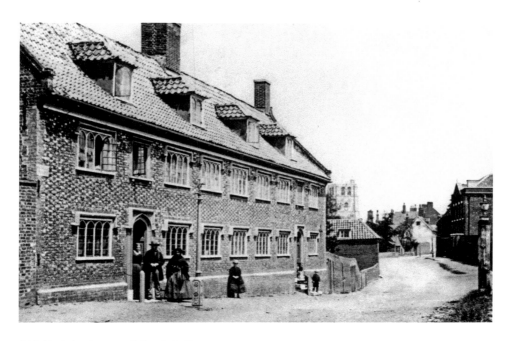

Old Sir John Leman School, Ballygate

This sixteenth-century building was already used as a school when Sir John Leman, a former Lord Mayor of London, left money in 1631 to educate forty-eight boys. Extensive alterations occurred to the structure's exterior in 1762. The institution had closed by 1908, but it became a Parents' National Educational Union (PNEU) school in 1947. The building has housed Beccles and District Museum since 1996.

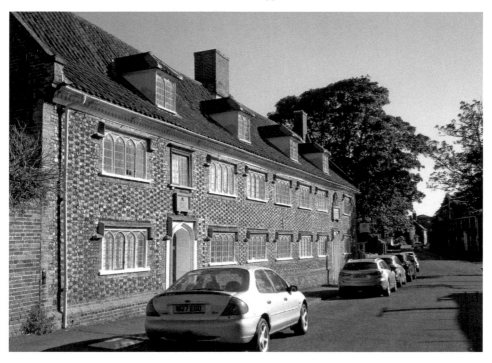

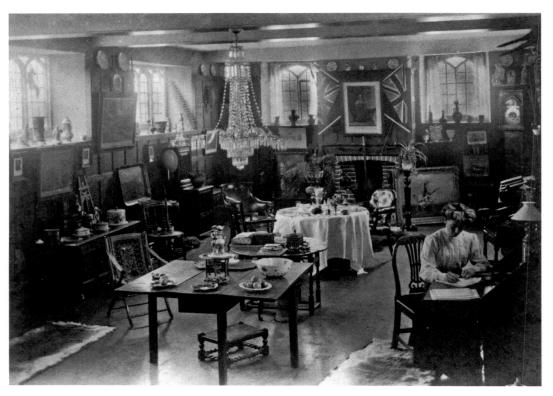

Inside the Old Leman School, Ballygate

This photograph shows the interior of the museum when it was a private house and doctor's surgery, rented by Dr Oscar Owles from 1910 to 1915. The lady in the picture may be his daughter. Polish troops occupied the house in the Second World War. The Feoffees of the Beccles Townlands Trust bought the building in 1993 and restored it.

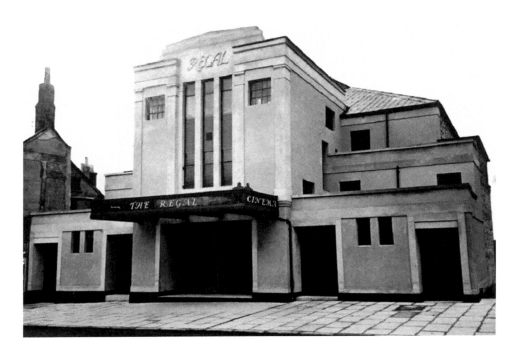

Regal Cinema, Ballygate

The cinema opened in 1931 on the site of the former Beccles College, which explains the name of the subsequent development: Old College Close. The building was modernised in 1975, but it closed the following year, remaining in use for some live shows and bingo. Demolition began in 1989 in spite of a spirited campaign to save what had been described at a council meeting as a 'neo-Egyptian monstrosity'. (Photo of cinema: courtesy of John Smith)

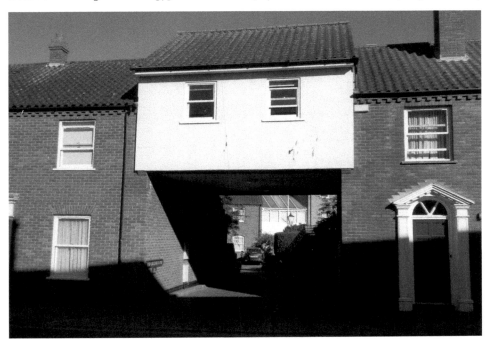

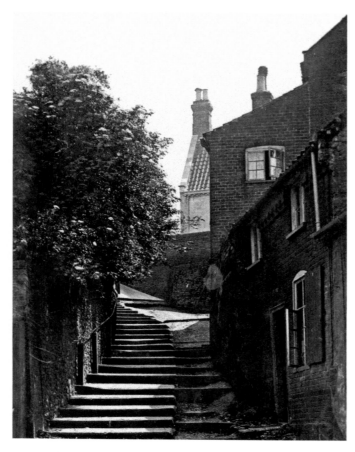

Stepping Hill, Puddingmoor
The small cottages that crept up the right-hand side of the steps were demolished in the mid-twentieth century. One of them, known as the 'Hole in the Wall', comprised a small room and a wash house that accommodated two adults and five children in 1878. An attractive garden now occupies the area where several of the cottages huddled together, and more spacious properties have been built at the lower end.

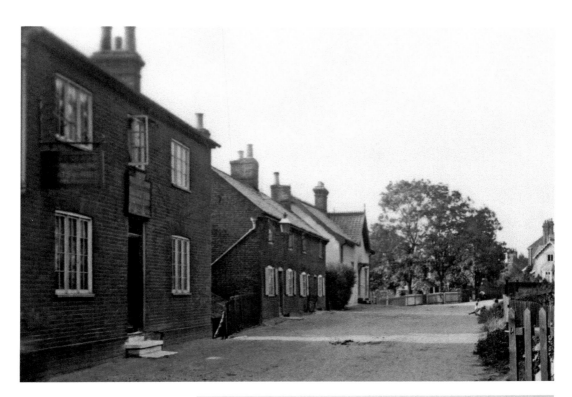

The Pickerel, Puddingmoor

The inn on the left was The Pickerel, known as such from the late eighteenth century until around 1970; previously it had been called The Dog House. It is now residential accommodation, retaining the Pickerel name, which means 'young pike'. A large stuffed pike had once graced the bar. The cottages to the inn's right were demolished in 1954. (Photo: Barry Darch)

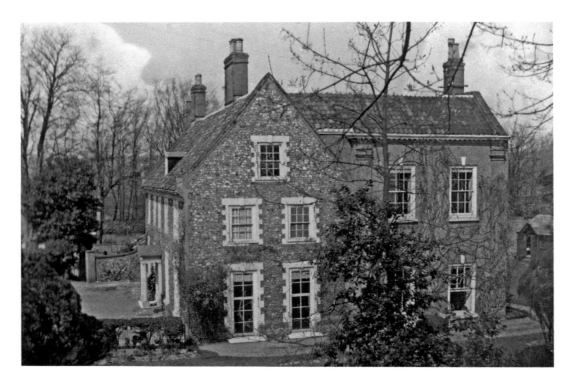

Waveney House, Puddingmoor, *c.* 1923

For most of its history the property has been a private house. William Leman, brother of Sir John, lived here in the reign of Elizabeth I. In the eighteenth century the grounds accommodated buildings for malting and brewing, and William Crowfoot (d. 1783), tanner and organist of St Michael's Church, became a brewer when he moved here. The building has been a hotel for sixty years. (Photo of house: courtesy of James Hartley)

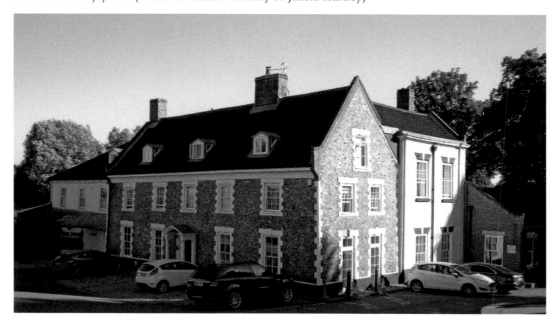

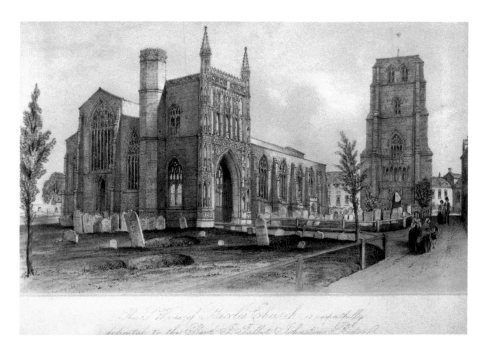

St Michael's Church, *c.* **1860**
St Michael's dates from around 1370. The elaborate porch, added eighty years later, is regarded as the building's greatest treasure. It was conserved in 2018, thanks to the dedicated fundraising of The Friends of St Michael's. Today St Michael's provides a wide range of church services and hosts many events for the town. (Photo: Barry Darch)

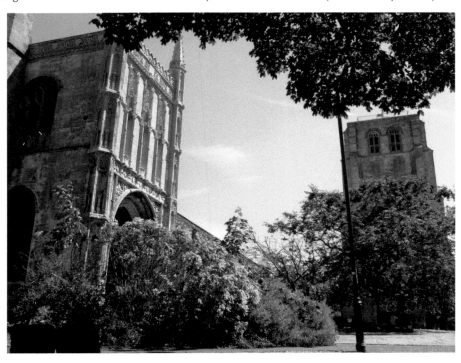

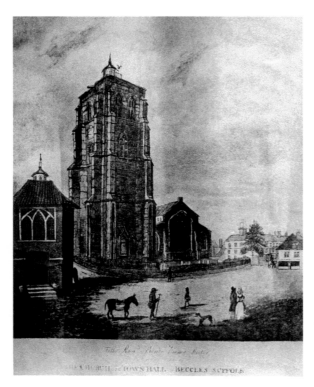

Town Hall and St Michael's Church, Early Nineteenth Century

The Town Hall on the left was built in 1766 and originally had the dual purpose of shire hall for sessions of the Justices of the Peace and town hall for the Corporation of Beccles Fen. Later it housed the library from 1875 until 1912, when it reverted to civic use, a function it retains today.

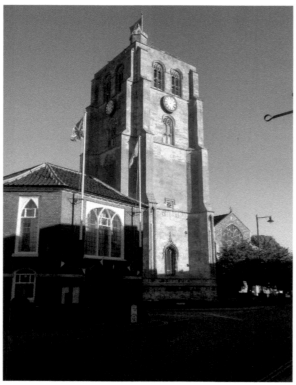

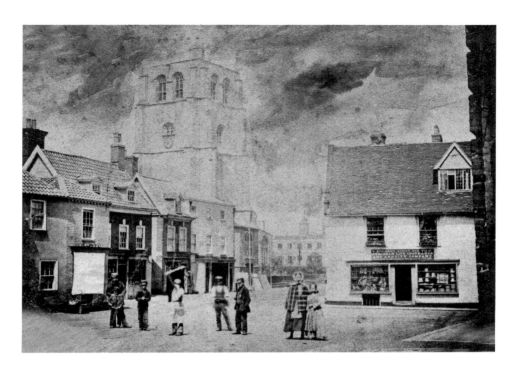

New Market, Mid-Nineteenth Century

The detached tower, begun in 1500, was sold to the borough council for a penny in 1972. Housing one of the finest ten-bell rings in East Anglia, it is often open on Saturdays in the tourist season for visitors to enjoy its far-reaching views. The sign above the shop of the hatter and tailor W. Holdron on the right proclaims that he is the agent for the European Life Assurance and Annuity Company. The shop was demolished in 1864 for road widening.

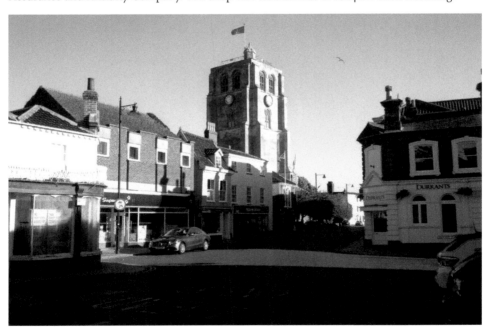

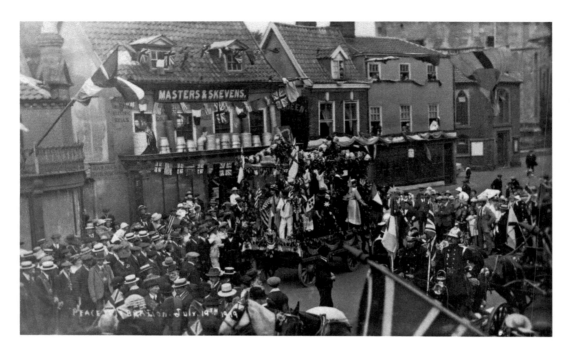

New Market, 1919

Beccles was full of noise and colour in July 1919, celebrating peace after the First World War. But there were different sounds and sights when Masters and Skevens' premises, which had been an ironmonger's for a century and a half, burned down fifty years later. The grocer William Crowfoot, ancestor of the medical family, had had a shop here in the 1690s.

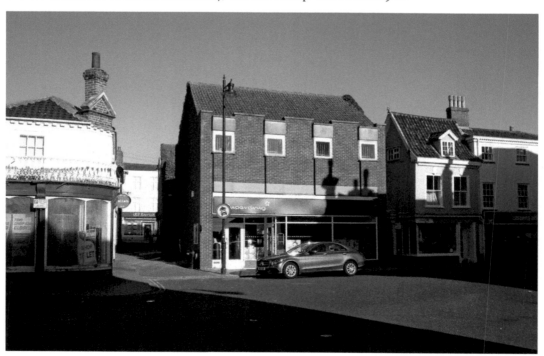

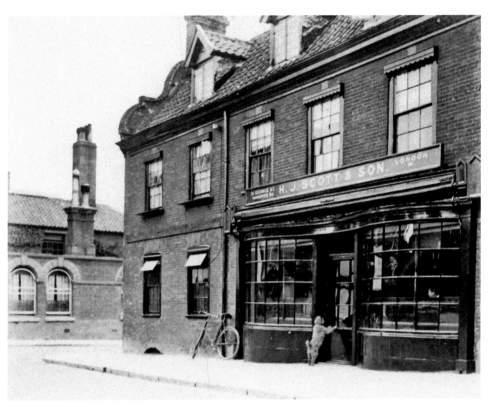

H. J. Scott and Son, New Market, c. 1910

The dog looking in at the door was not excited at the sight or smell of food, as this was a large tailor's establishment from around 1860 until the 1950s. Afterwards the premises became a wine and spirit merchant's shop and later a supermarket, as it remains today. The Red Lion traded here in the seventeenth century. (Photo: Barry Darch)

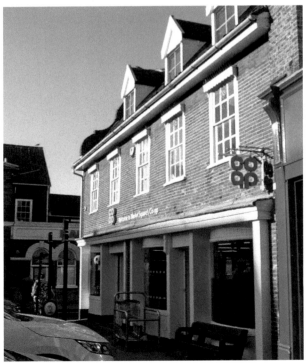

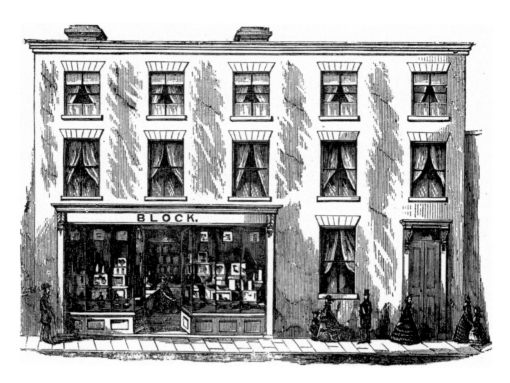

Block the Grocer, New Market

The premises of grocer Robert Block, built in 1863, were described in the local paper as 'containing a large and commodious shop, very handsomely fitted and well arranged'. The Midland Bank (now HSBC) was built in 1921, following in the footsteps of earlier banks that had operated here many years before.

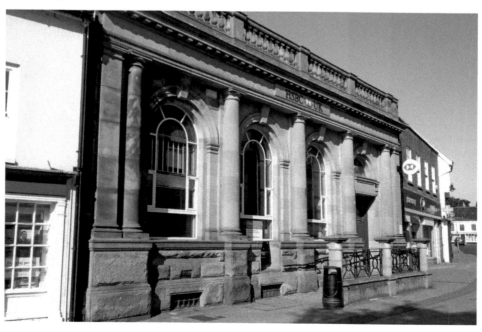

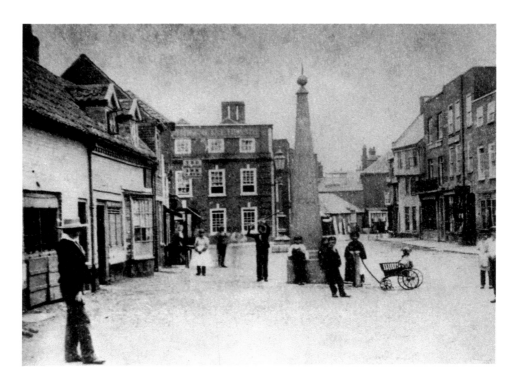

New Market, *c.* 1865

The pump shut in 1876 after the water was deemed unfit. The buildings on the left had supplanted butchers' stalls, of which there had been fifty-one in 1659, set out in four rows. Can you see the projecting sign of The Dolphin Inn to the left of the pump? Today the ringing of estate agents' phones has replaced the clink of tankards and thud of the cleaver. (Photo: Barry Darch)

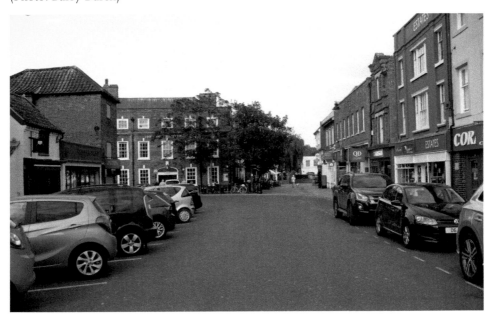

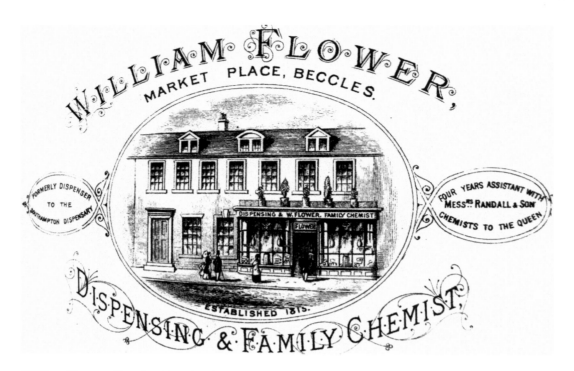

William Flower, Chemist, New Market

Flower's shop had been a chemist's since at least 1841, run then by J. B. Corbyn, a descendant of a long line of East Anglian tailors, from whom Jeremy Corbyn also descends. Flower took over in 1866. It has continued as a chemist's to this day, but Boots replaced the old building in 1962.

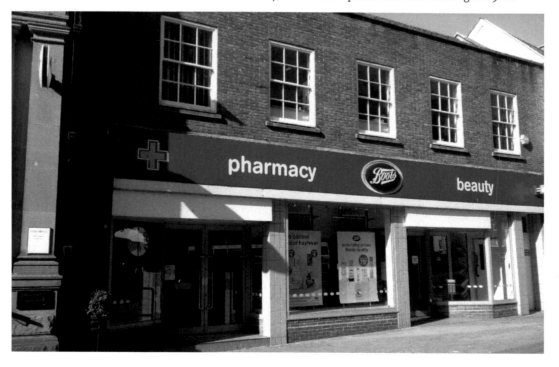

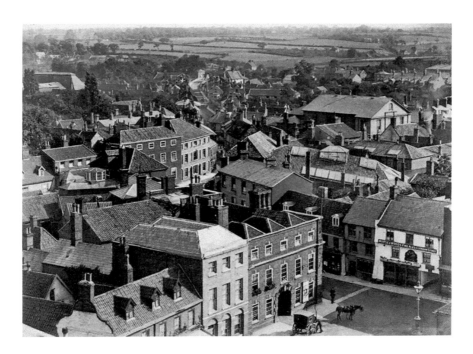

View from the Bell Tower, Looking South-East

The view of around 1900 shows bottom right the pale front of The Falcon, described in 1725 as 'an ancient and well-accustomed Inn'. It was popular with herring fishermen returning from sea, and in the 1930s its mechanical piano encouraged noisy sing-songs. The inn was demolished in 1963. Above the roofs of the adjacent buildings can be seen the skylights of the Corn Hall. (Photo *c.* 1900: courtesy of Ian Hollingsworth)

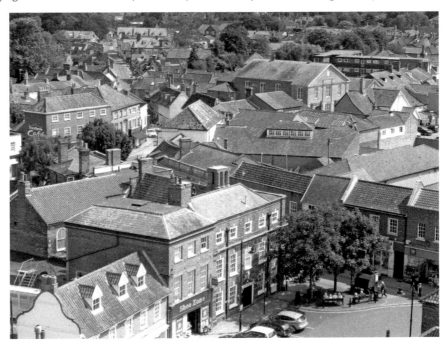

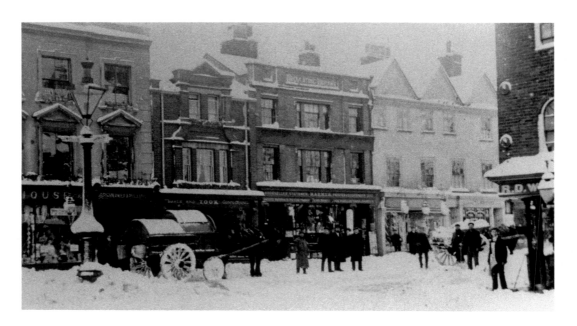

New Market in the Snow

New Market and Sheepgate grew in the late fourteenth century after the Abbot of Bury St Edmunds sold farmland here, perhaps to help complete the rebuilding of St Michael's Church. In contrast with centuries of commercial activity, the gas lamp had a short life, from 1883 to 1917. Perhaps the wagon was the corporation dustcart performing winter work.

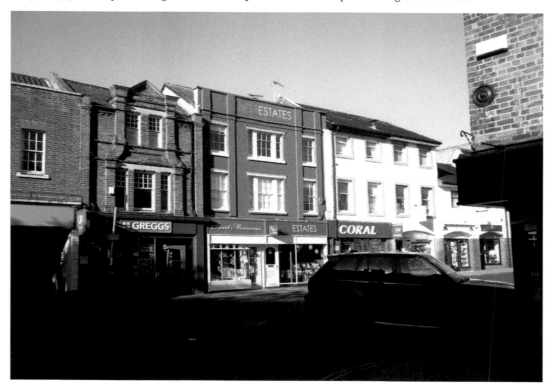

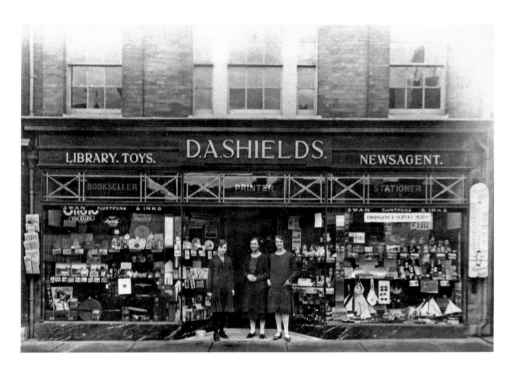

D. A. Shields, New Market

In the 1930s Donald Shields was a bookseller and stationer here, running a circulating library and selling 'Beccles crested brass ware' and the 'largest selection of local view postcards in the district'. The shop had been a bookseller's since the 1830s, when it was built, but earlier it had been part of The White Lion, a substantial inn. Today sweets and houses are on sale in the divided premises.

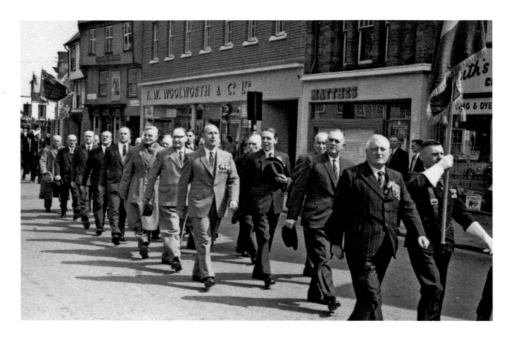

New Market, Eyes Right

Most of the former servicemen are looking at a figure on a podium and avoiding the attractions of Woolworth's. In the late nineteenth century Womack Brooks ran his drapery business here, advertising corsets made in Hungate Lane with the slogan 'Support Beccles Industries'. The adjacent shop of Matthes had been a baker's since at least 1775 and remains so today. Ex-servicemen still parade through New Market but not this particular stretch. (Photo of servicemen: Leslie Freeman)

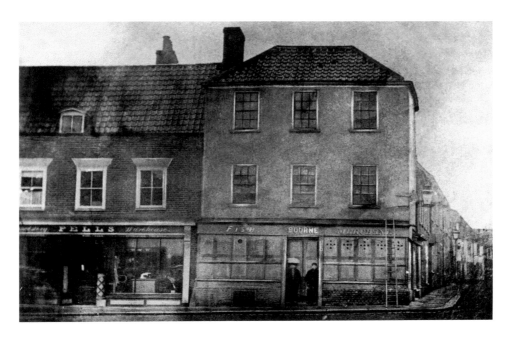

Bourne, Fish Merchant, New Market, c. 1865

The town's first purpose-built bank, originally Gurney's, replaced the shop of Bourne, the fish merchant, in 1868 – one kind of scales replacing another. The bank's exterior has changed considerably since it was first built, with the removal of elaborate balustrading and a balcony, but it is still a functioning bank. (Photo: Rix Collection)

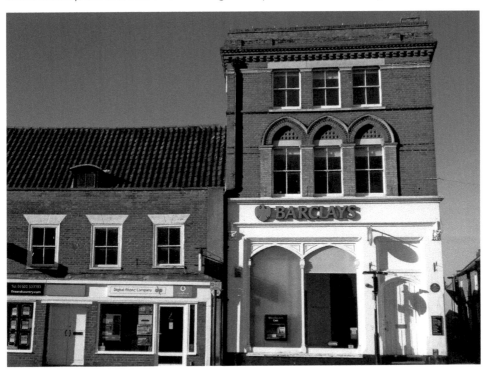

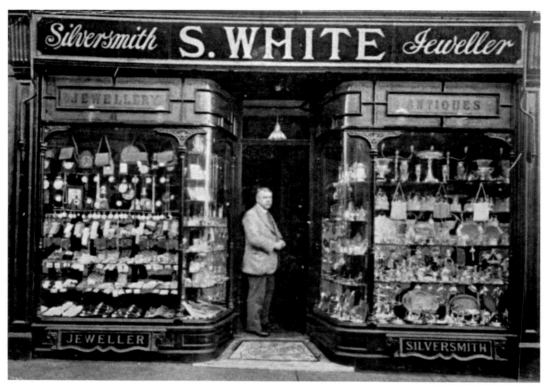

Samuel White, Jeweller, Sheepgate
Samuel White had a jeweller's shop here from the 1890s, retiring in 1940, aged eighty-one. The words 'Ye Olde Shoppe' are still visible in the floor of the entrance. Today the empty shop, until recently a greengrocer's, awaits absorption into the King's Head. White had a considerable private collection of antiques, which the author Rudyard Kipling came to see in 1913.

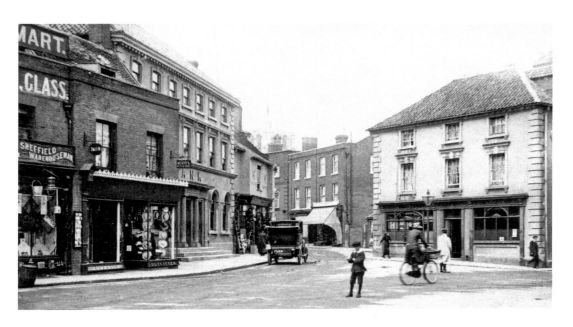

Exchange Square

Behind what is now Lloyds Bank on the left stood the Fisher Theatre, which became the Corn Exchange in 1845. In the middle of the picture is part of the King's Head, the town's largest inn since the days of Charles II. Here in 1786 the diarist Parson Woodforde enjoyed some of the finest Colchester oysters he ever saw. The large building on the right, the post office when this picture was taken, was demolished for road widening in 1938.

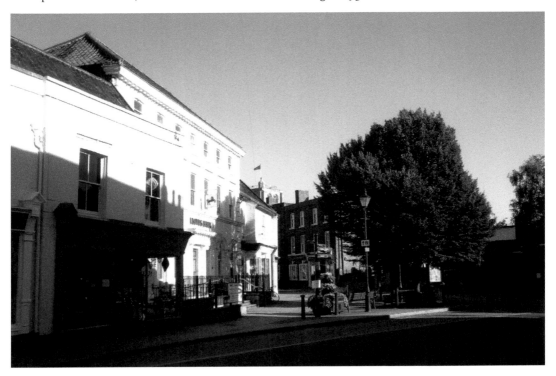

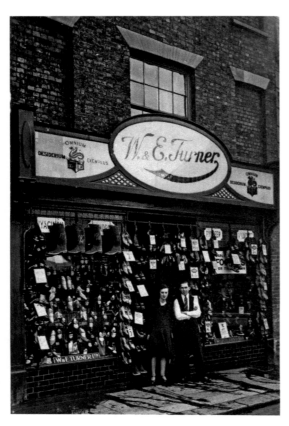

Turner's Shoe Shop, Exchange Square
W. E. Turner Ltd, a national chain, sold boots and shoes here in the 1920s and 1930s. It was not the first such chain to operate in Beccles as Stead and Simpson were trading in New Market before 1900. W. E. Turner's Latin motto may look impressive, but it has defied translation by several scholars! Today's funeral parlour has a less cluttered look. Jewellers and florists had colourfully preceded it.

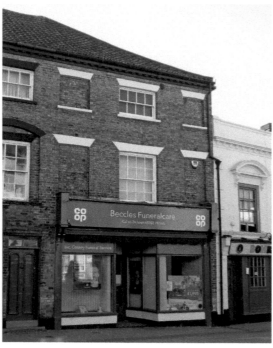

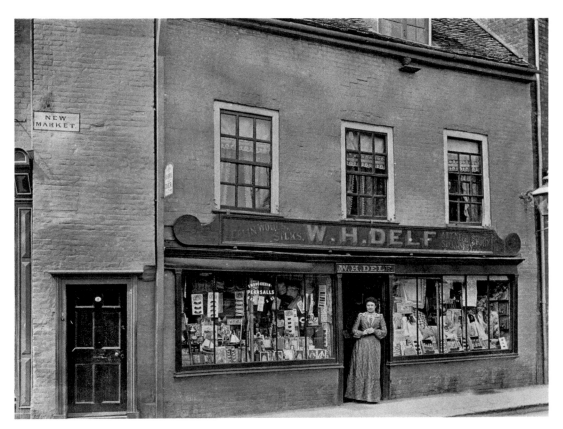

W. H. Delf, New Market

At the end of the nineteenth century William Delf had his name above the shop, but this 'fancy depository' was run by his wife and later by his daughter Evelyn into the 1950s. He himself was a mechanical engineer. Later the building became the home of different kinds of deposit – financial ones, as it housed first a bank and then a building society.

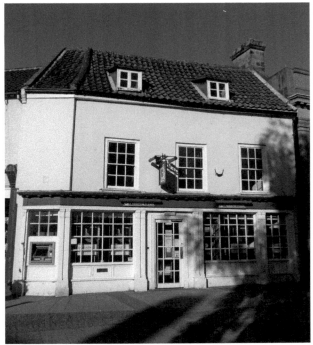

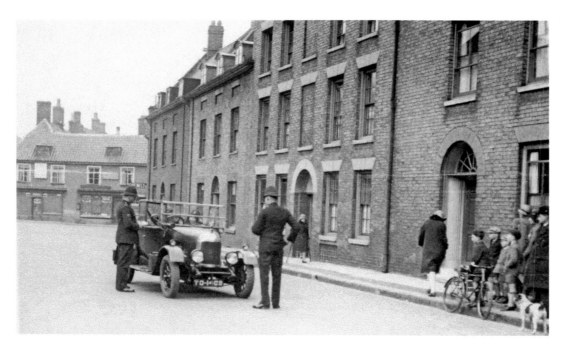

The Walk

You would have been much more likely to encounter a policeman or two in 1930s Beccles, as this driver found! The Walk, sometimes known as Gentleman's Walk, was less commercial then than today. The Georgian façades belie the medieval origins of the street, which linked together the town's two market areas.

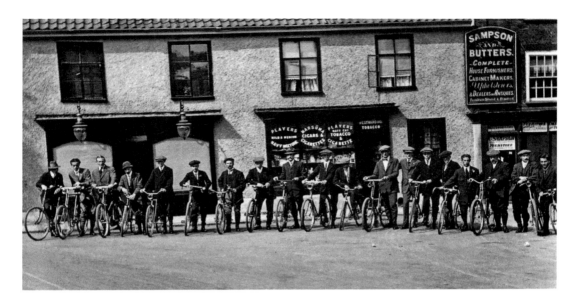

Cyclists in Rook's Lane

The cyclists of a century ago appear to be in their best clothes and not dressed for much exertion. Today's equivalents, members of a Beccles U3A group about to set off to Lowestoft, are much more informally attired. The buildings in the older photograph were part of Rook's Lane, which jutted out towards Saltgate before being demolished for road widening. (Photo: Barry Darch)

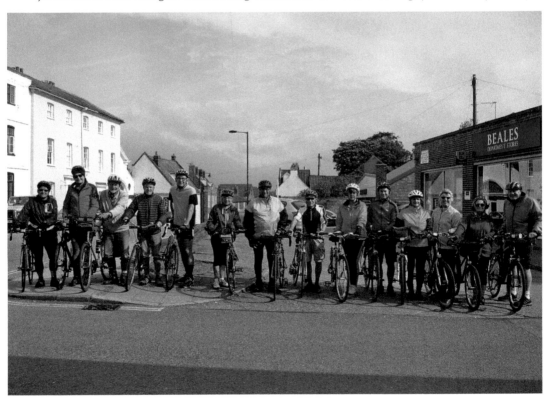

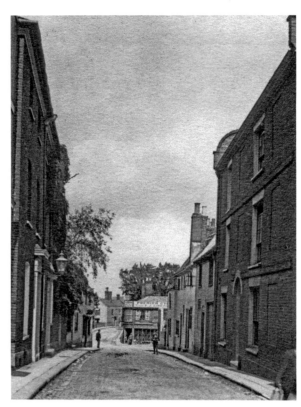

Saltgate, Looking North
The houses on the right were pulled down in 1938 for road widening. The largest of these was occupied by the eccentric Jarrett Dashwood in the mid-nineteenth century. He seems to have lived off money which had come from his wife's family, but he restricted her spending, refusing to pay a draper's bill, which resulted in a court case. He lost. (Photo: Barry Darch)

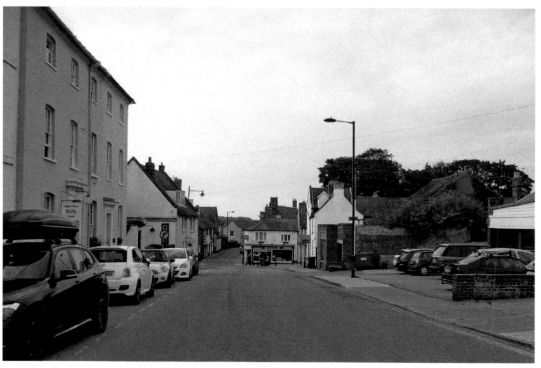

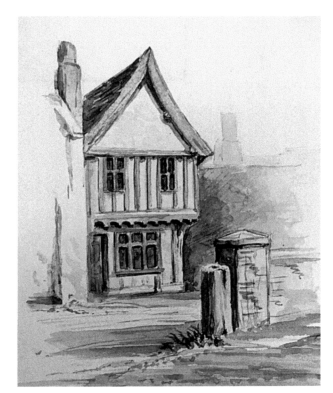

The Pope's Head, The Score
Little is known of this small inn
which later became The Griffin.
A lane to the right of the building
led to the boatyard of John
Jones, whose son Samuel became
headmaster of the Sir John Leman
School in 1848 in his mid-twenties.
After a time as a building
company's offices, the former
inn is today a neat private home.
(Painting: Rix Collection)

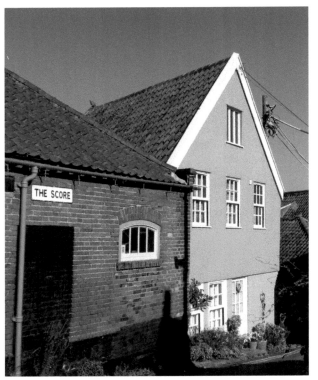

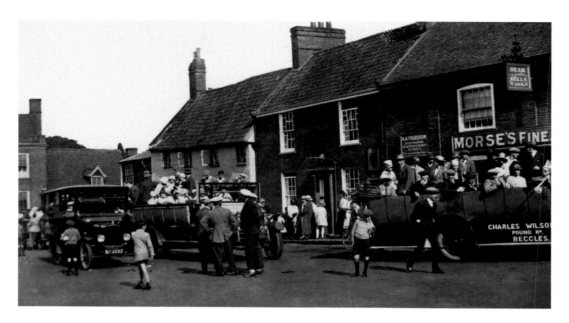

Old Market, *c*. 1925

Old Market was the ancient home of Beccles traders, probably from late Saxon times. It was still a market in the nineteenth century, particularly for livestock. In the 1790s several large trees shaded raised walkways on either side of the area. Travelling shows could be seen here in the later Victorian period. Today frequent buses have replaced the occasional charabanc.

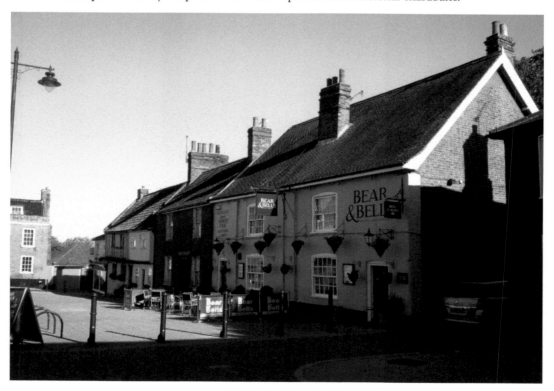

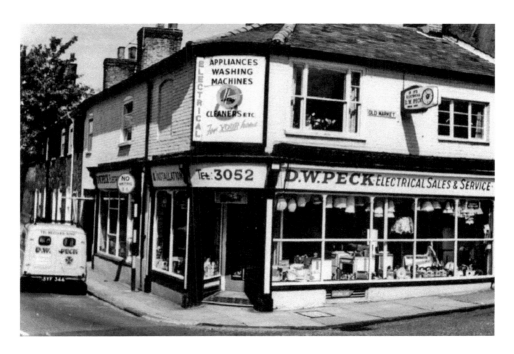

D. W. Peck, Old Market

Douglas Peck ran his electrical business here for four decades, retiring in 1999. Earlier this had been the bicycle shop of Percy Gibbons. Today the community-based project Sharel, managed by the Norwich charity STEP (Standing Together Empowering People), sells donated furniture and refreshments and offers advice and support. (Photos: Douglas Peck; Barry Darch)

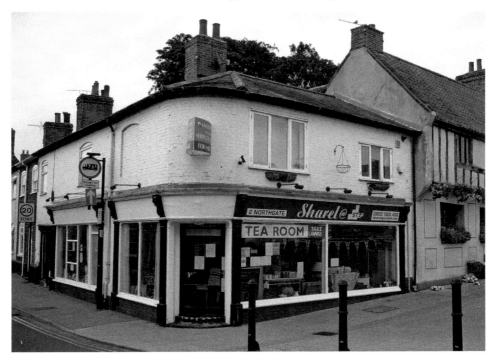

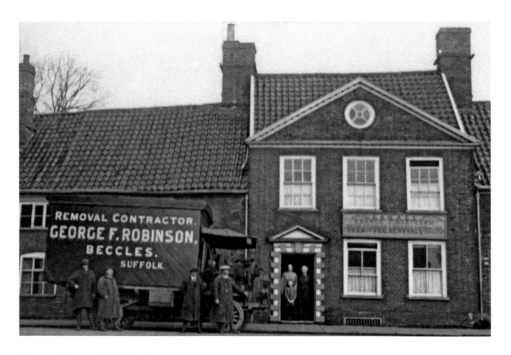

Surrey House, Old Market

G. F. Robinson, who hailed from London, came to Beccles in the 1920s and established a large haulage business. His vehicles were kept behind the property with access from Smallgate. The eighteenth-century house had previously accommodated a laundry and in the 1880s it had been the home of Robert Jarman, printer – and tax collector. (Photos: courtesy of Richard Barret; Barry Darch)

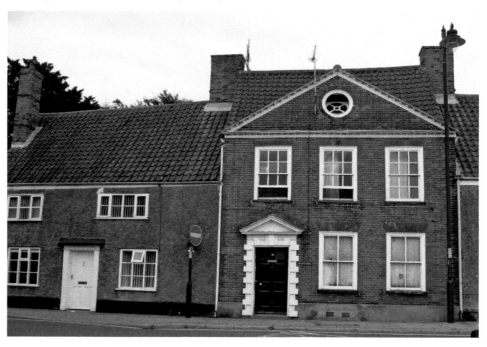

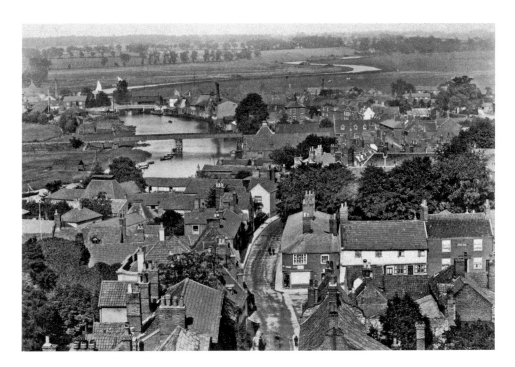

View from the Bell Tower, Looking North

The northern part of Beccles was more industrial in the late nineteenth century, as the buildings crowding down to the eastern bank of the river indicate. The trees in the middle of the picture to the right stood in the large garden of Northgate House, one of the delightful Georgian houses that still adorn Northgate. (Photo *c.* 1900: courtesy of Ian Hollingsworth)

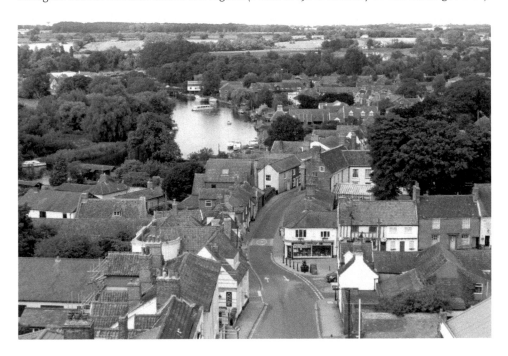

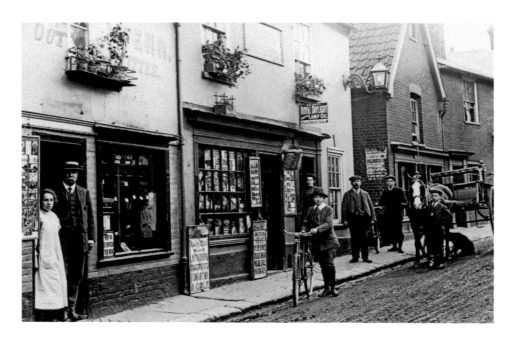

Northgate Shops, 1909

On the left is Walter Fenn, whose tailor's shop also contained a small post office. The newspaper boards outside the neighbouring grocery refer to the Frenchman Hubert Latham, who on 22 October 1909 attained a speed of over 80 miles per hour in Blackpool, a flight described as 'the most daring ever attempted'. Residents of Northgate hope that their determined campaigning will deter motorists from flying down their ancient street at more than a quarter of Latham's speed.

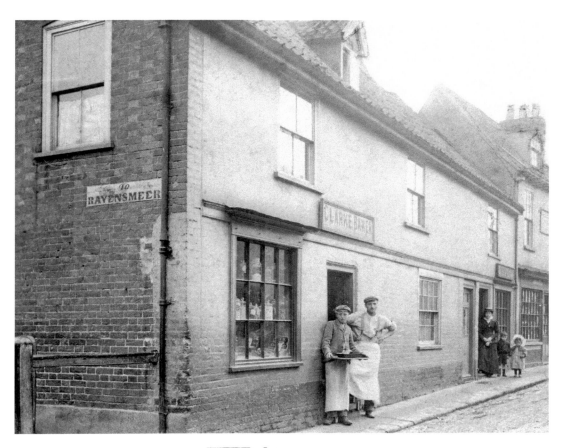

Clarke's Bakery, Northgate

This was a bakery for well over 200 years from at least the 1750s. The taller baker is believed to have been Charles Clarke, who was baking here in 1896. By 1901 his brother Daniel had taken over the premises and was described as baker and shopkeeper. Today all the many shops that once enlivened Northgate are private houses, except an optician's practice that had been a grocery store in Victorian times.

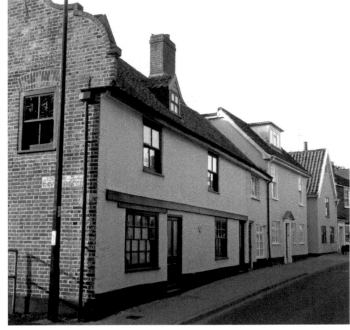

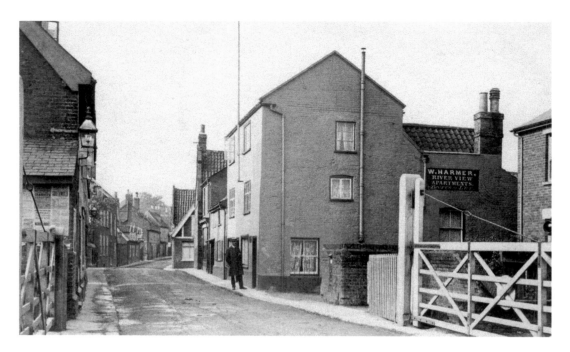

Rail Crossing, Northgate

Here the Waveney Valley Line crossed Northgate before going over the river and into Norfolk. It went to Bungay and Harleston before reaching the main line to Norwich at Tivetshall. The line closed to passengers in 1953 and completely in the 1960s after over a century of existence. Children who waited patiently for the gates to open were sometimes given sweets by the rail staff. Today a house called Crossings marks the site.

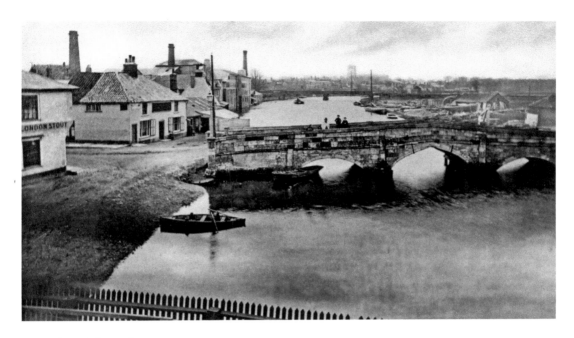

The Bridge Before 1884

The stone bridge, actually brick faced with stone, was built in the late fifteenth century. At its east end on the south side stood a chapel and hermitage, occupied in the 1460s by William Ward, 'hermit of Beccles'. Later the hermitage became a public house, but in 1970 it was replaced by the present private dwelling, which has retained the ancient name.

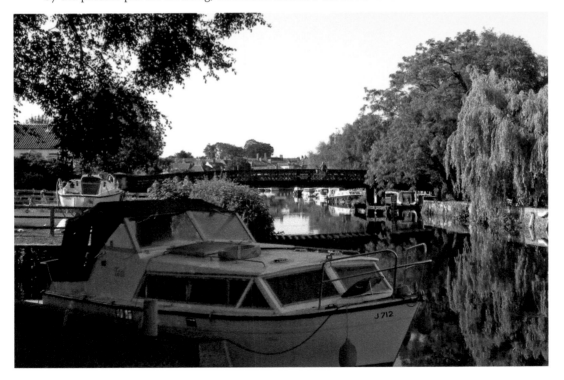

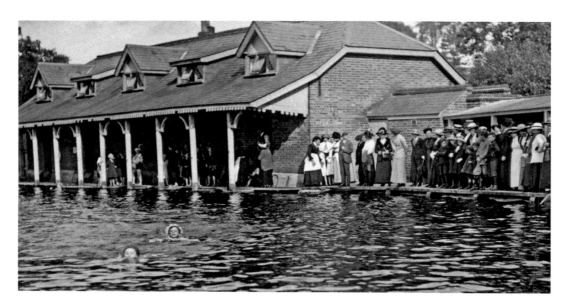

The Bathing Place

The Bathing Place was built in 1894, providing much better facilities than the old granary previously used for changing. The current pool was constructed near the Bathing Place in 1959. The facility was taken over from Waveney District Council by Beccles Lido Ltd, a community-run charity that reopened it in 2010. Since then it has gone from strength to strength.

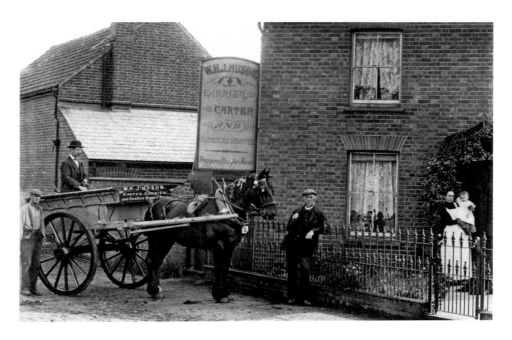

William Huson, Carter, Ravensmere, *c.* 1900

William Huson was a carter and carrier whose business was taken over by his son-in-law, William Clarke, after he died in 1903. The photograph shows William Huson by the railings and William Clarke in the cart. William Clarke's wife, Elizabeth, is holding baby Edith Huson Clarke. The road on the left leads to the ancient pound where stray animals were once placed. (Photo: Barry Darch)

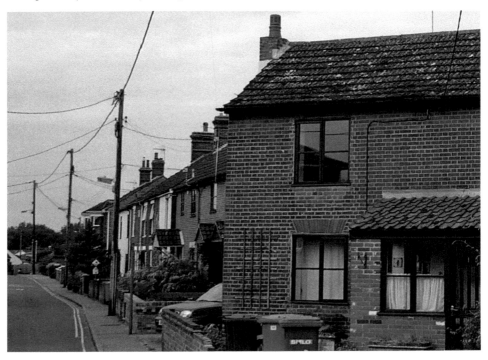

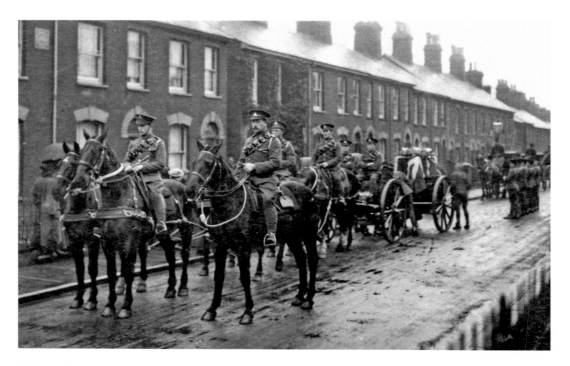

Military Funeral Procession, Denmark Road, 1915

The photograph shows the military procession for the funeral of Corporal Alexander Judge of Denmark Road who had joined the 6th Suffolk Cyclists at the start of the war. He had died in Lincolnshire from an infection treatable with antibiotics today. Denmark Road developed from 1879 as part of the town's significant growth in the later Victorian period. Today it remains a residential road.

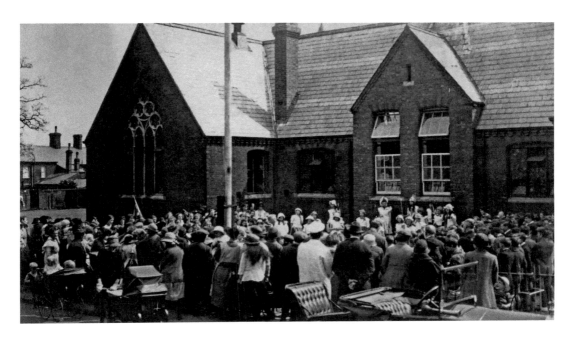

The National School, Ravensmere, Empire Day 1925

The school opened in 1868 and closed in 1939, when it was converted into a fire station. At its opening the school was described as 'a handsome roomy structure'; no doubt it was much more spacious than the previous school in Newgate. The building was demolished in 1960 and a new fire station built. This was extended in 2017/18 to include a police station.

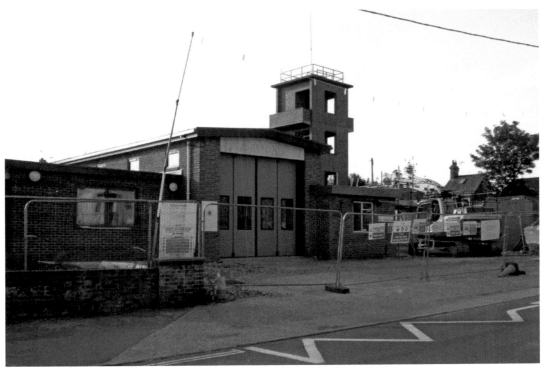

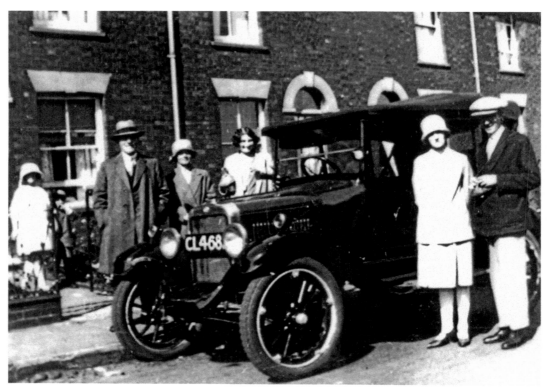

Knights Family, Caxton Road
The Knights family lived at No. 45 Caxton Road in the 1920s when this photograph was taken. Arthur Knights was a barge wherryman. His son Kenneth, dressed in an overcoat, was visiting from Norwich with his family. Caxton Road took its name from the adjacent printing works and developed from the late 1860s. Cars have changed but the appearance of the houses very little.
(Photo of family: courtesy of Gillian Wilkin)

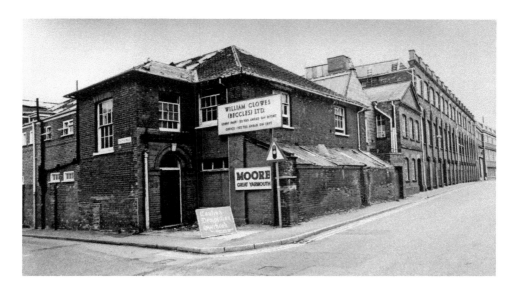

Clowes, Newgate

The relationship between members of the Clowes printing family of London and Beccles began in 1873 when two of them went into partnership with William Moore, who had moved his Caxton Printing Works to Newgate in 1867. The company expanded after each world war and had over 1,000 staff in 1972. It moved to Ellough in 2004 and Tesco opened in 2005. (Photo of works: Leslie Freeman)

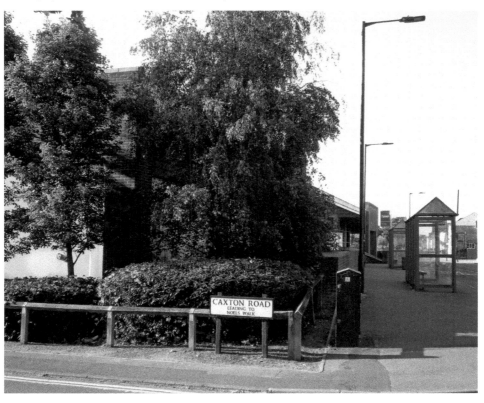

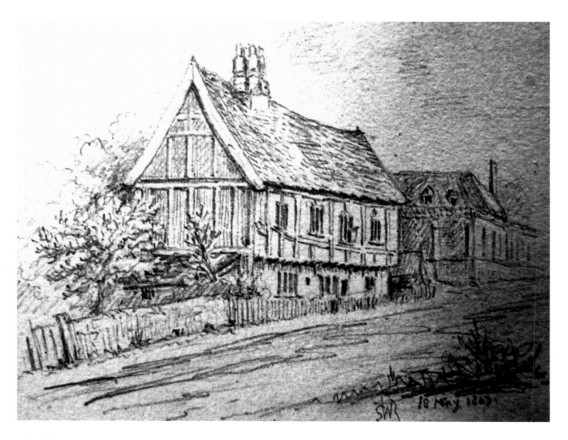

The Manor House, Newgate

This 1867 drawing by S. W. Rix shows the building shortly before it was demolished and replaced by the Caxton Printing Works. The building was probably an Elizabethan structure, built by one of the Rede family who had acquired the Manor of Beccles after the dissolution of the Abbey of Bury St Edmunds. The Gaol is visible on the right. (Drawing: Rix Collection)

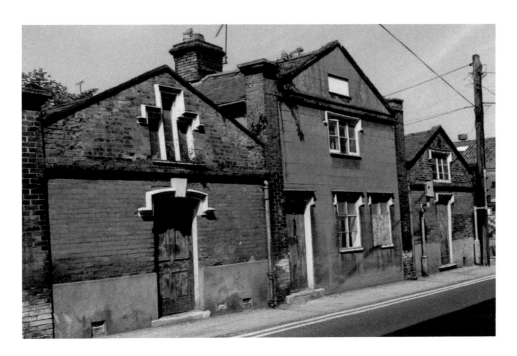

The National School, Newgate

The three buildings of the National School were erected in 1837, the master's house being in the middle and the rooms for boys and girls on either side. Both sexes were taught to knit and mend their clothes. The school closed in 1868, the boys' part becoming the Working Men's Newspaper and Reading Room. By 2000 the buildings had deteriorated, but their appearance has now improved significantly, matching the redevelopment of the area. (Photo of buildings before improvement: Richard Bellefontaine)

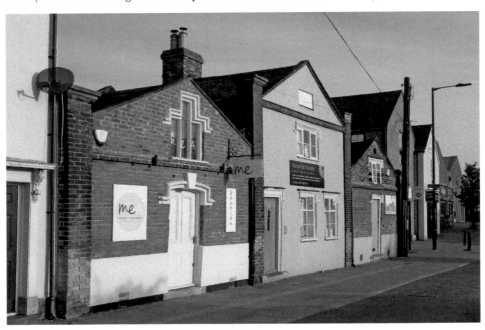

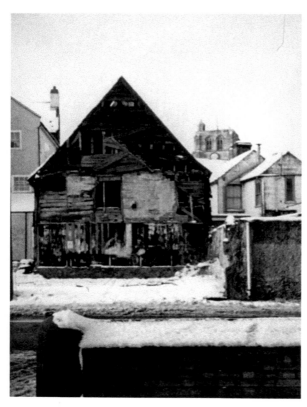

The Guildhall Barn, Newgate
The barn lay on Newgate behind the Guildhall itself, which was on Smallgate. The Guildhall was rebuilt in 1837, but the ancient barn survived until 1985, when it burned down. Plays could be seen in the barn in the eighteenth century, as when *Romeo and Juliet* was performed in 1749. The barn was later used by the White Lion and its successors for various purposes. (Photo of Barn: Mary Youngman)

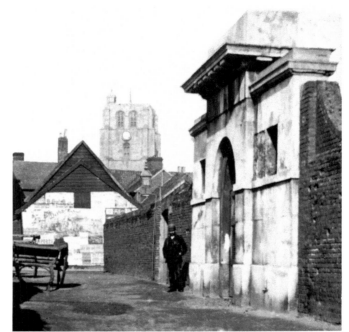

The Gaol or House of Correction, Gaol Lane, 1896
On the right is the gaol gateway, above which was the Latin inscription '*Prohibere Quam Punire*' (To prevent rather than to punish). The gaol was built arond 1800, replacing an earlier structure, the deficiencies of which had been highlighted by the prison reformer John Howard on his visits. The last prisoners left in 1861 and the building subsequently housed the town's police station and courthouse. It was demolished in 1937, but the gateway remained until 1960. (Photos: William Goffin; Barry Darch)

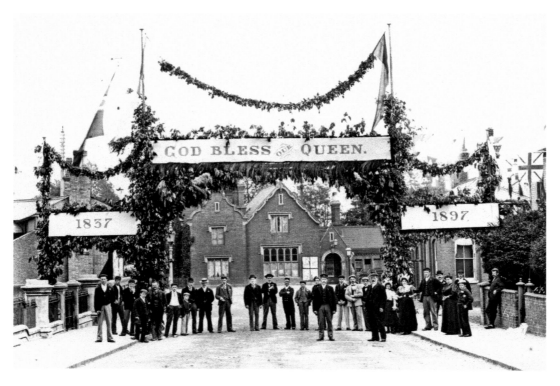

Beccles Station, 1897

The station buildings were completed by the summer of 1854. By the end of the century the station had been extended, but the main buildings facing Station Road had changed little. More recently, after some time as a furniture salesroom, the buildings reopened in 2016, providing a social enterprise café and rooms to hire for meetings as well as office space upstairs. (Photo: Barry Darch)

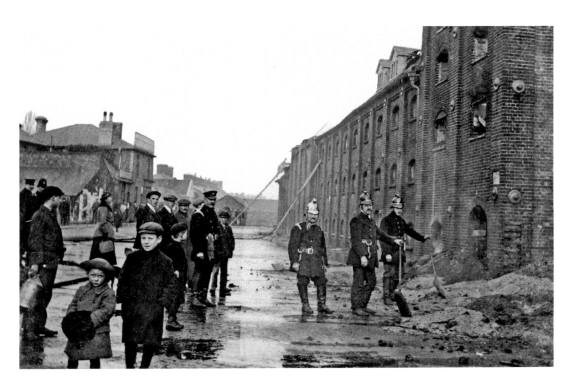

Fire at the Maltings, Gosford Road, 1912
The fire extensively damaged the maltings, which had been built in the 1860s. The architect for the rebuilding was Frederick Skipper of Norwich, who also designed Sir John Leman Grammar School. The maltings were demolished in 1996. Today a mixture of housing occupies the large site. (Photo: Barry Darch)

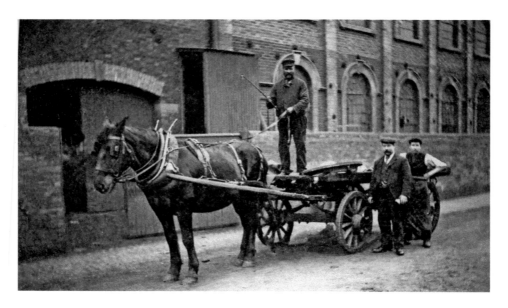

The Ingate Ironworks, Gosford Road, *c.* 1910

William Elliott, mechanical engineer, moved his premises to Gosford Road in 1873. By 1901 the company was specialising in the manufacture of steam capstans and employing 300 men. It celebrated its centenary in 1968 but was taken over in the 1970s. Today, its former premises are used by a variety of local businesses.

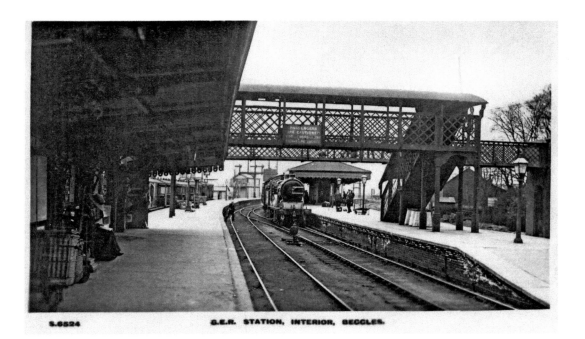

S.6524 S.E.R. STATION, INTERIOR, BECCLES.

Beccles Station, Looking North, *c.* 1920

The station was much more extensive a hundred years ago, not least because it served lines to Tivetshall and Great Yarmouth as well as the remaining Lowestoft to Ipswich line. Both passenger and goods traffic was extensive. After decline in the second half of the twentieth century, a passing loop was created at Beccles in 2012, facilitating an improved service.

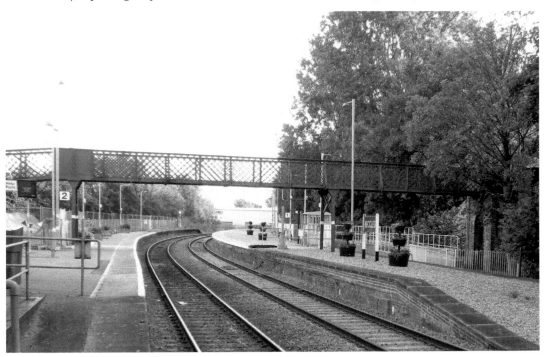

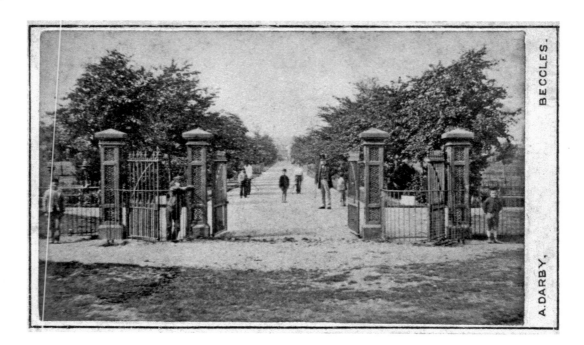

The Avenue Gates

Created in 1867, The Avenue became a favourite area for a stroll in one's Sunday best, the three swans, purchased by the borough council to swim in the ornamental water, adding to the tranquillity. The mayor considered that employing old men to make the path had probably saved them from the workhouse. A more recent civic head, Graham Catchpole, chose the restoration of The Avenue as his mayoral project in 2016–17. (Photo: Barry Darch)

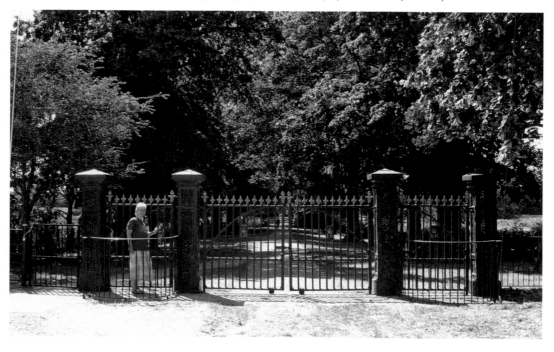

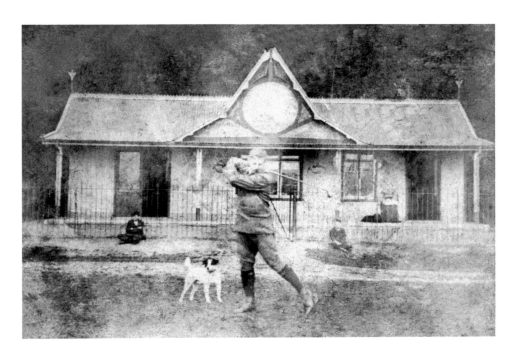

Golf Club, the Common

The Golf Club, begun in 1899, continues successfully today, using the original wooden clubhouse, which has been extended. Gorse bushes on the course offer some interesting challenges! Behind the clubhouse lies Boney's Island, used for a bonfire in 1814 to celebrate prematurely the end of the war with Napoleon Bonaparte. (Photo: Barry Darch)

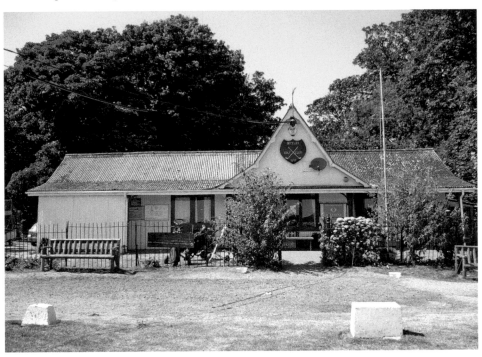

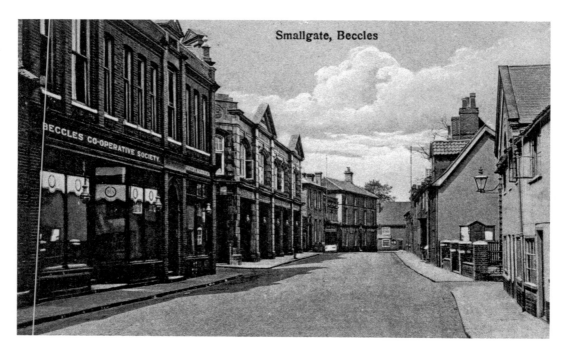

Smallgate, Beccles

Beccles Co-operative Society, Smallgate

The Beccles Working Men's Co-operative Society opened the 'Central Premises' in Smallgate in 1896. The Drapery, Furnishing and Confectionery block was added in 1913 and the Butchery extension, with Assembly Hall above, in 1926. The society was particularly proud that its Clothing Club had helped kill 'the baneful giant Credit'. The society sold the business to Beales in 2011.

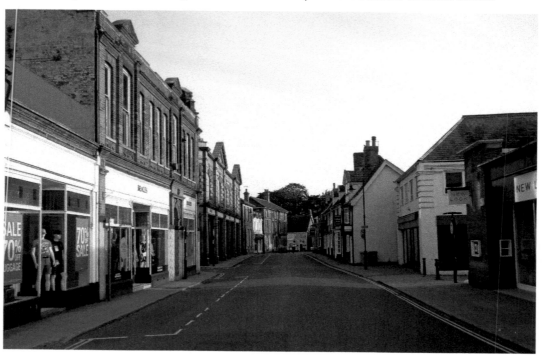

Primitive Methodist Chapel, Smallgate
An almshouse burned down here in 1699, when 100 properties were destroyed. The Primitive Methodists erected their chapel in 1872 to accommodate the congregation that had outgrown their Peddars Lane building. Taylor's Electrical took over the premises when the chapel closed and traded during the second half of the twentieth century, shutting in 2013. Today Keith Skeel sells furniture, gifts and antiques.

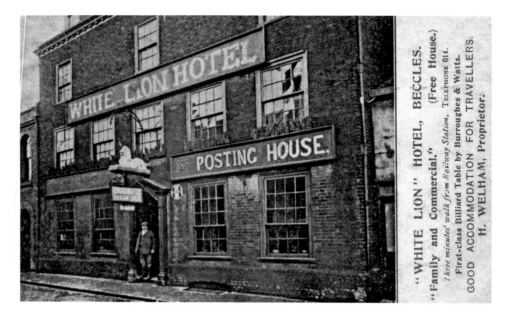

The White Lion, Smallgate

The White Lion was built in around 1790. In 1815 the landlord, Robert Chipperfield, employed a singer from the Drury Lane theatre in London to entertain customers in his 'Rural Gardens' on the south side of Gaol Lane. The inn closed in 1961 and was bought by Beccles Borough Council. The upper floors were converted into flats and the ground floor became a restaurant and later the Harvester Club. Today the ground floor is also residential. (Photo: Barry Darch)

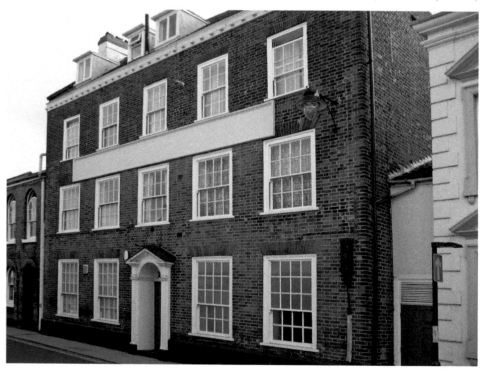

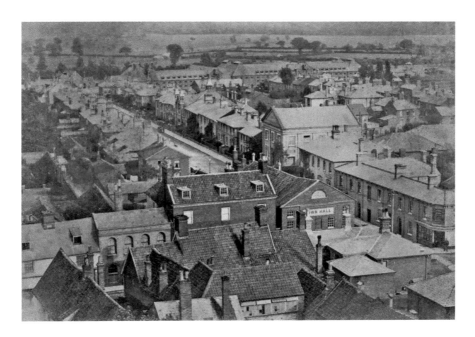

The Former Assembly Room

The building with the name 'Town Hall' is known today as the Public Hall. It was erected as the Assembly Room in 1785 to draw wealthy people to the town. Many famous performers have appeared on its stage, including Sir John Mills when a Beccles schoolboy. The hall, acquired by Beccles Lido Ltd in 2013, benefits from the support of a large team of dedicated volunteers. A diverse programme of events is provided. (Photos: *c.* 1900 courtesy of Ian Hollingsworth; Barry Darch)

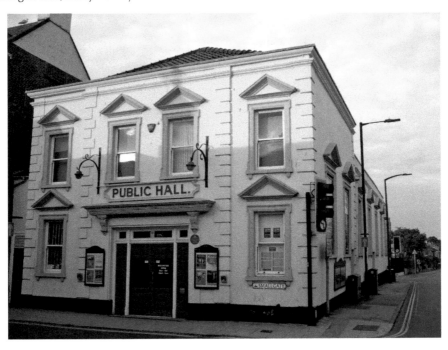

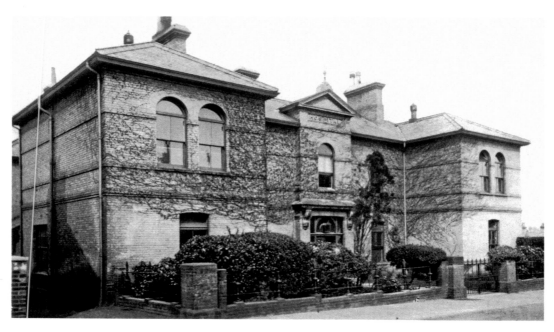

The Hospital, Fair Close

The building opened in 1874 but fifty years later was too small and was divided into houses. The town's annual Hospital Fete, which provides additional resources for the current hospital, has its roots in the fundraising that supported the earlier premises, such as a fete of 1899 that included a bicycle gymkhana. Fair Close was the site of fairs held from medieval times until around 1870.

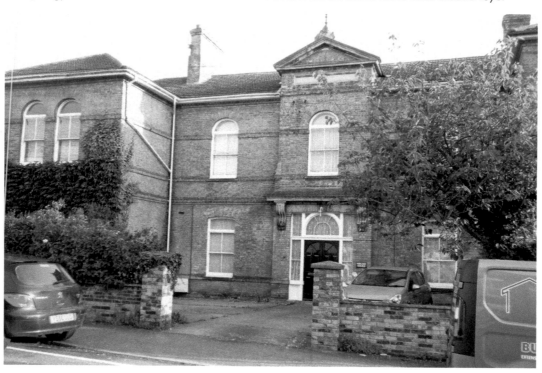

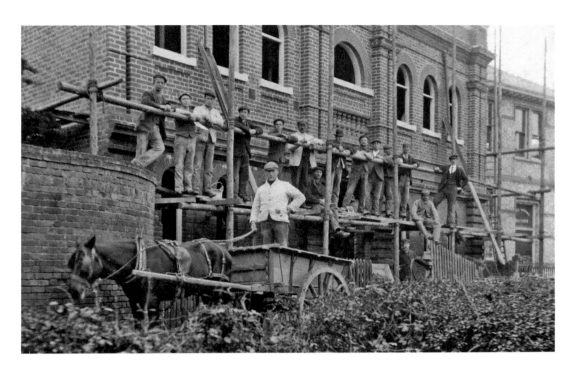

Men's Social Institute and Lecture Hall, Fair Close

The institute was built by William Elliott of the Ingate Ironworks in 1902 and had 250 members within two years. The lecture hall, shown under construction, was added in 1904. 'The Tute' had closed by 1960 and the Co-op Dairy used the site. Today bungalows known as Clowes Court occupy the site where both buildings had stood, but the institute's bowls club still survives nearby.

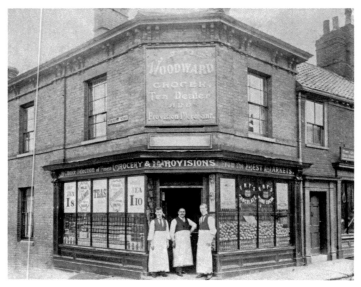

Michael Woodward, Grocer, Station Road
Michael Woodward stands between two of his staff in around 1900. The property was described as 'newly erected' in 1861. By 1911 George Reynolds Gipson had taken over as grocer and the shop traded with the Gipson name for half a century. The Needlecraft Shop, which opened in 1967, has also achieved this milestone. (Photo of grocer: courtesy of David Woodward)

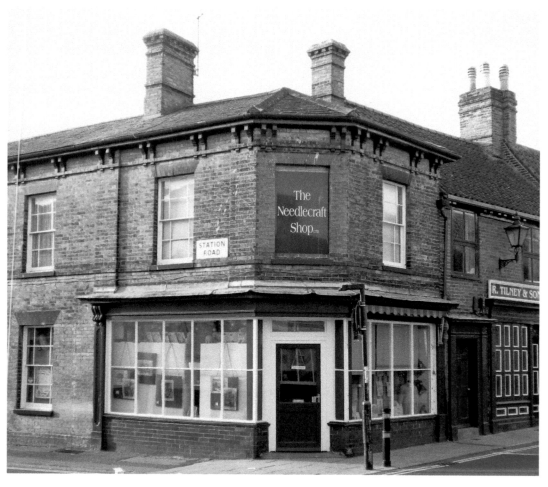

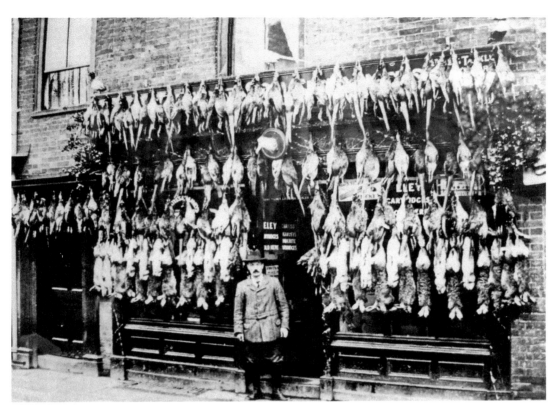

Harry Tilney, Gunsmith, Smallgate
Harry Tilney, described as a gunsmith and taxidermist in the 1901 census, stands among a huge array of game. The gun-making business was founded by Robert Tilney, Harry's father and great-grandfather of the present proprietor, also Robert, well known for his appearances on BBC's *Antiques Roadshow*. (Photos: courtesy of Robert Tilney; Barry Darch)

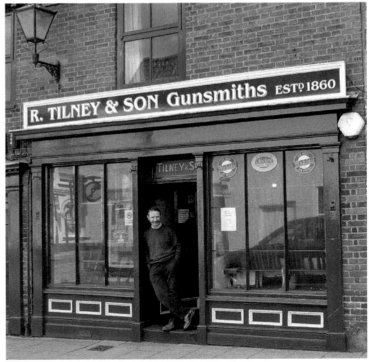

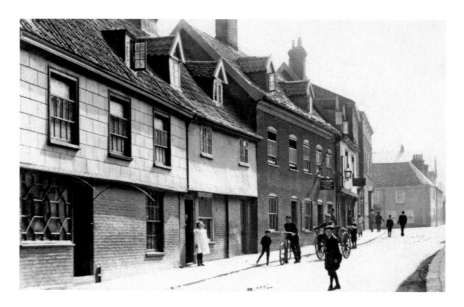

Smallgate, Looking South, *c.* 1910

The part of the brick building to the right of the centre of the photograph with the barber's pole was occupied by Herbert Leeder from around 1900 to the late 1920s, when his premises and the adjoining Prince of Wales Inn on the right were demolished to make way for the post office. Herbert moved next door. This part of the brick building was also demolished, when the post office was extended in 1965.

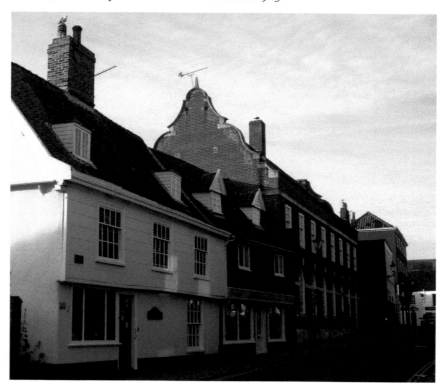

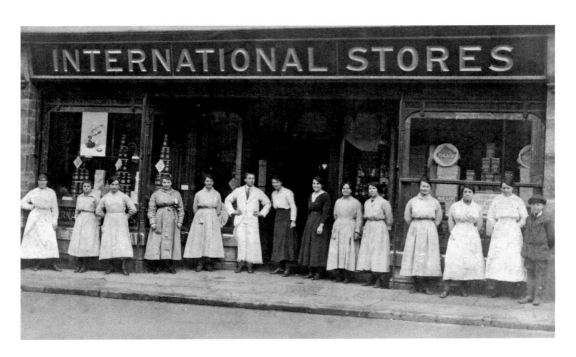

International Stores, Smallgate

The property, previously a dentist's home and surgery, with a back entrance on a carriageway leading into Newgate, was sold to International Stores in 1910. The photograph probably dates from the time of the First World War, when women took over many of the jobs in shops previously undertaken by men. The building was demolished in the 1970s, when the current structure was built. It closed as the National Westminster Bank in May 2018.

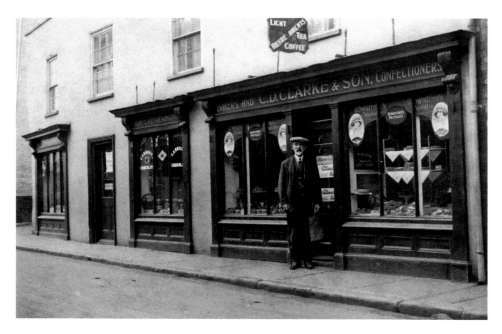

C. D. Clarke and Son, Bakers, Hungate, *c.* 1930

The premises had been a bakery for over a century when the Clarkes took over in the 1920s. The man in the picture is Edward Taylor Wigg, who was the father-in-law of the baker. For the last thirty years Hungate Health Store has operated here, selling less fattening food than Mrs Money's 'unequalled' biscuits made in the 1890s.

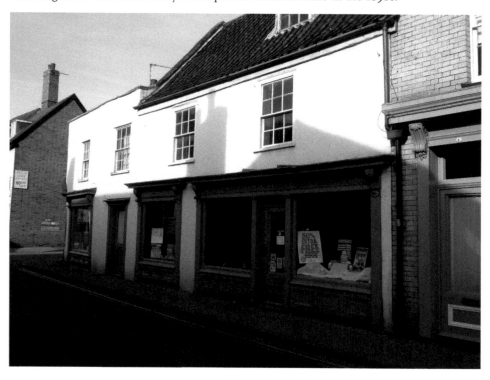

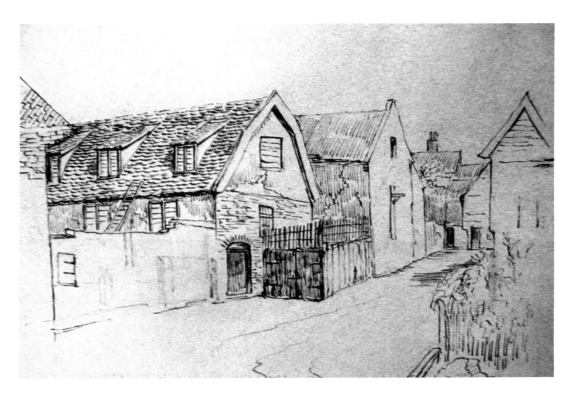

The Cockpit, off Hungate Lane

Cockfighting took place in the building called The Cockpit in the eighteenth century. John Wesley preached here in 1776, for want of anything more suitable. It stood in what is now the area of car parking behind QD but was associated with The Falcon inn on the other side of the alley from Newmarket to Hungate Lane. The building later housed a printing business. (Drawing: Rix Collection; photo: Barry Darch)

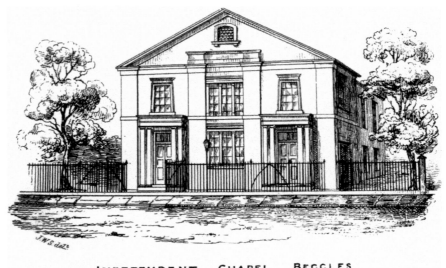

INDEPENDENT CHAPEL, BECCLES.

The Independent Church, Hungate, 1836

The first chapel on the site was described as newly built in 1696. A new chapel was erected in 1812, and the façade was enlarged in 1836, as in the drawing by J. W. Shelly. In 1879–80 the adjoining hall was built. The chapel became a Methodist and United Reformed Church in 1977 and is now known as Hungate Church. (Drawing: Rix Collection; photo: Barry Darch)

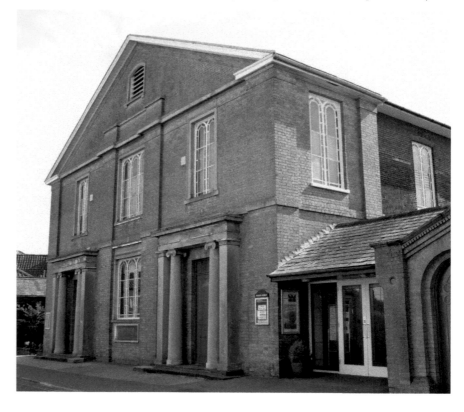

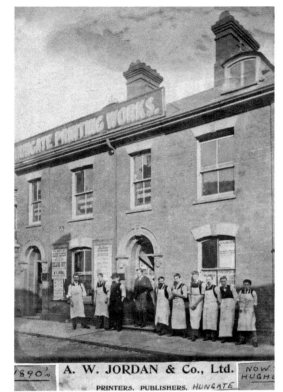

Hungate Printing Works, Hungate, *c.* 1898
Arthur Jordan established his printing
works in Hungate in 1885, but the company
had closed by 1904. In the photograph
he stands in front of the door. Next but
one on the right is apprentice Arthur Pye,
who became a printer's reader and mayor
of Beccles. The building has had many
subsequent uses and is a hair and beauty
salon today.

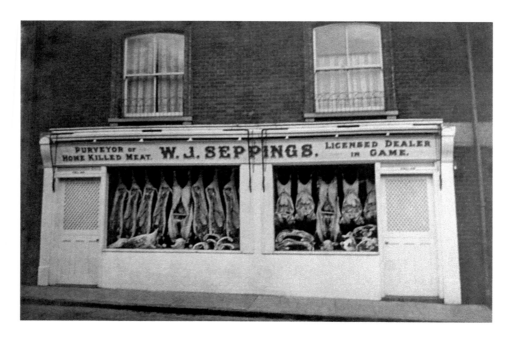

Seppings, Butcher, Hungate

William Seppings, from a long line of Norfolk butchers and cattle dealers, set up his business in 1919, having been the butcher at a local army camp during the First World War. He married the daughter of Samuel Field, who had run an iron foundry on the site. William's son Roger succeeded his father, and Roger's son Robert is the present proprietor, still using William's sausage recipe. (Photo: courtesy of Robert Seppings)

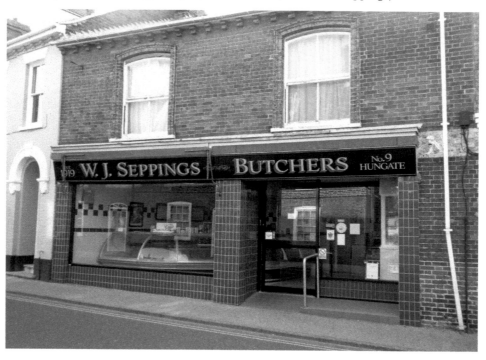

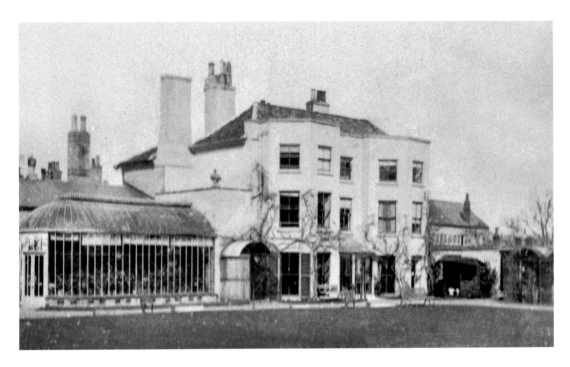

Mr Crisp's House, London Road
The house was built in the second half of the eighteenth century. The rector of Beccles, Bence Sparrow (who changed his name to Bence Bence in 1804), lived here. Later it was owned by John Crisp, corn merchant and maltster. The building became the Beccles Working Men's Conservative Club in 1911. (Photos: courtesy of James Hartley; Humphrey Manning)

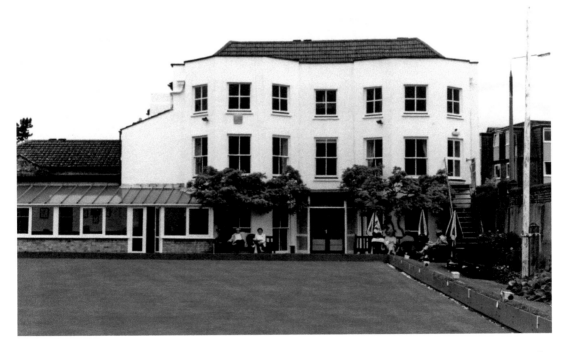

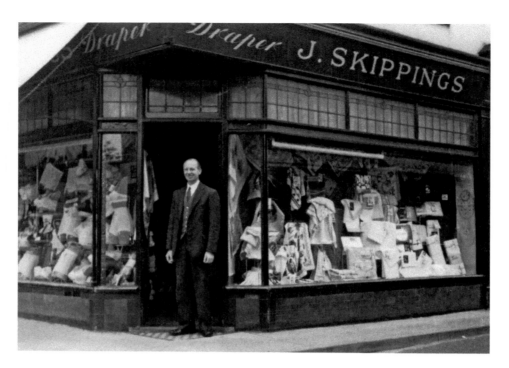

John Skippings, Draper, Blyburgate

The current building dates from the 1930s, when earlier premises, which had included a bicycle factory in the early 1900s, were demolished. The photograph of around 1960 shows John Skippings. Later his daughter Gill took over the business. Today a gift shop operates here. (Photo of draper's shop: courtesy of Gill Campbell)

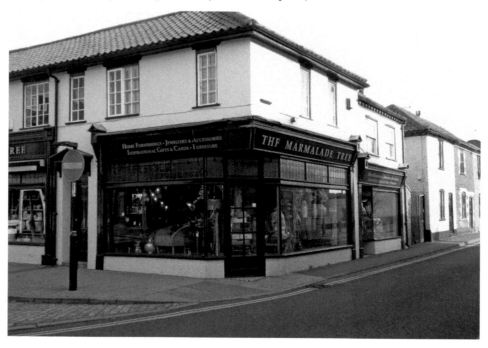

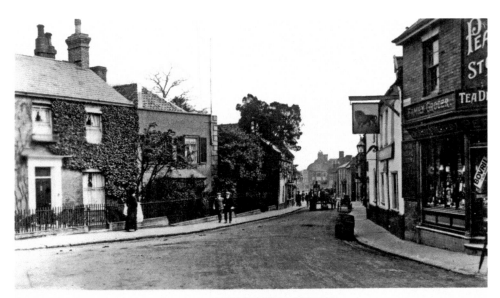

BLYBURGATE, BECCLES.

Blyburgate, Looking South-East

The building with the flagpole was owned in the seventeenth century by Lieutenant-General Fleetwood, who married Oliver Cromwell's daughter. Part of the premises served as the town's Labour Exchange in the 1960s and 1970s. Today the building has reverted to residential accommodation. On the right is The Red Lion, later to house Harry Warner's shoe repair and leather business. Now it is a barber's, its name of 'Redz' echoing its public house past.

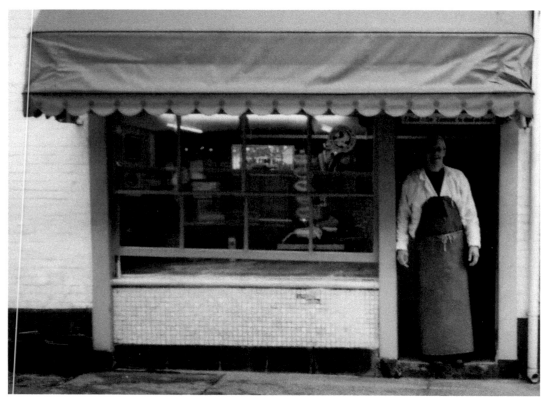

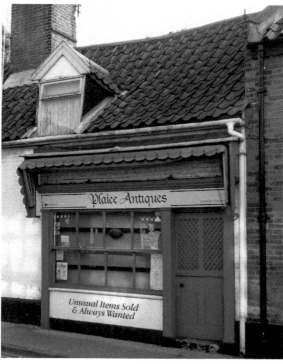

Neech, Fishmonger, Blyburgate
This 300-year-old building accommodated the Neech fishmongers for over a century until the shop closed in 2007, David Neech being the last proprietor. The name of the current business, Plaice Antiques, commemorates the fishy heritage, but you won't smell a kipper here now. (Photo of fishmonger's shop: Irene Ellis)

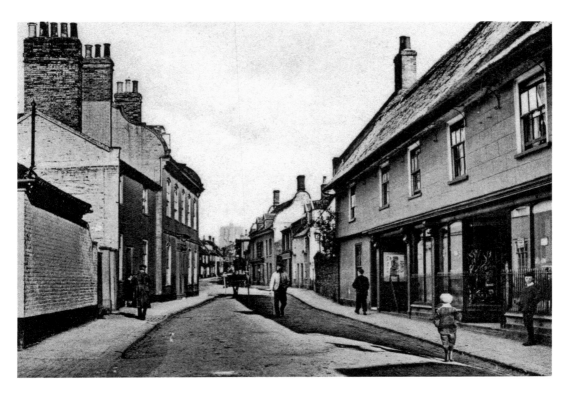

Blyburgate, *c.* 1900

This view of Blyburgate was taken in around 1900. The property on the right was The Thatched House, for many years a draper's business. It burned down in the 1930s. The Wood Hill Memorial Homes were built on the site in 1951–52, commemorating a popular local doctor and mayor. On the left was Blyburgate House, the grounds of which stretched as far west as London Road. Today an arcade of small shops stands here.

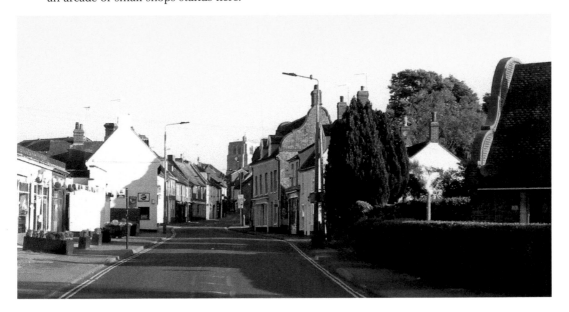

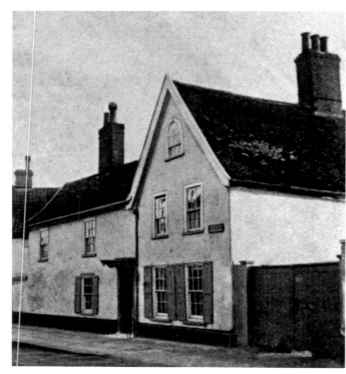

Oakley House, Blyburgate
Oakley House was occupied by Revd Peter Routh when he became the first headmaster of the Fauconberge School in 1770, and the school was initially conducted on the premises. The building was replaced by Oakleigh House in 1898, built by Dr Crowfoot to accommodate a junior doctor, George Fox, who became the prime mover in the establishment of the Beccles Adult Schools in the early 1900s.

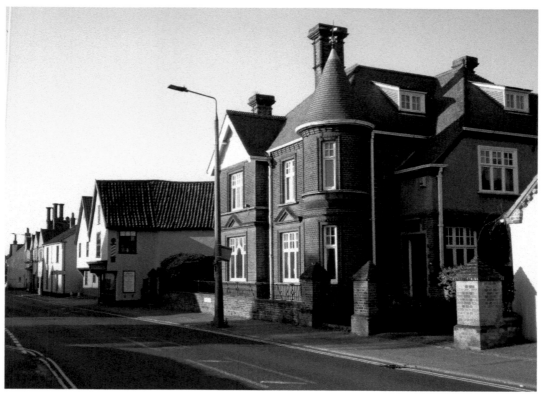

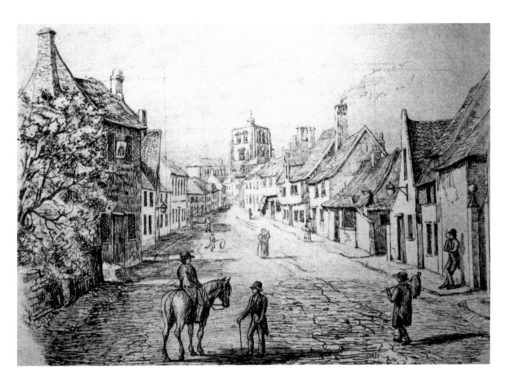

Blyburgate, Looking North-West, c. 1834

Blyburgate, the ancient road to Blythburgh, was already established as a street in the early fifteenth century. The Crown (dating from the seventeenth century when a family of candle makers lived there) is on the left and is today called Half Crown House. The tall building to the left of the tower is what is now Hungate Church. (Drawing: J. W. Shelly, Rix Collection)

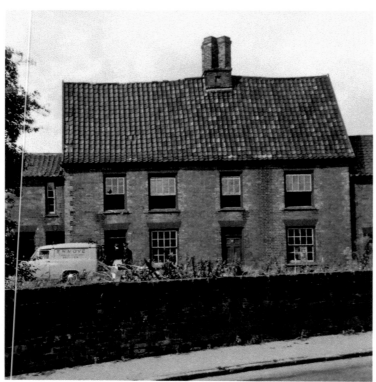

Nightingale Farm, Blyburgate
Nightingale Farm took its name from a family occupying it in the sixteenth century. The farmhouse had been later subdivided, probably in the mid-1800s when a brick front was added to the timbered building and two cottages were built on the right. All but these cottages (recently turned into one house) were demolished in 1958 to make way for the Salvation Army Hall. (Photo of former farmhouse: Mary Youngman)

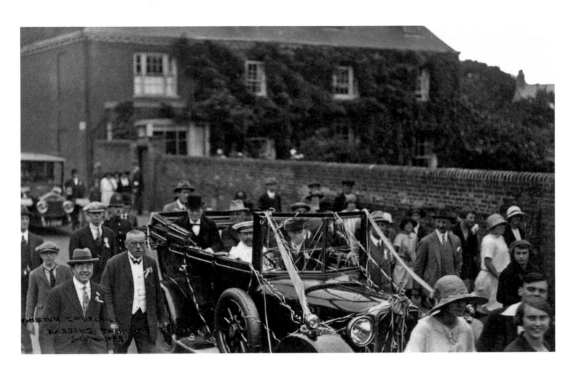

Churchill in Blyburgate

Winston Churchill visited Beccles in July 1925, when Chancellor of the Exchequer. The late eighteenth-century Kilbrack House in the background was occupied at the time by the Durrant family of auctioneers. It became the offices of the borough council in 1947 and survived a serious fire in 1971. Today it houses the property company Dencora.

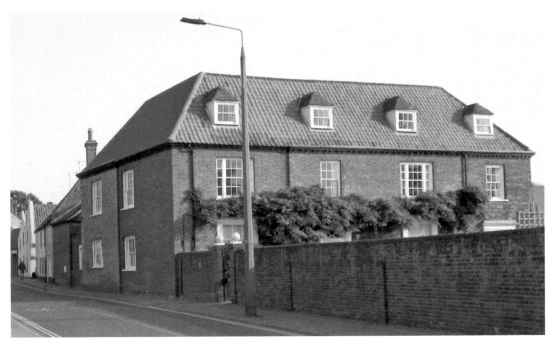

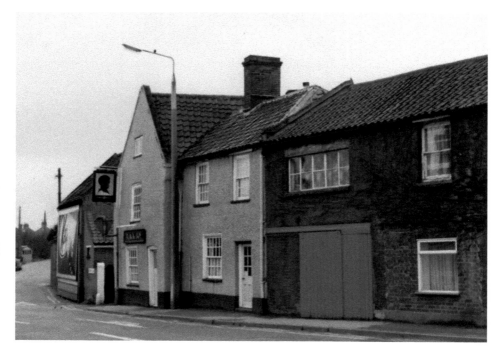

The Black Boy, Blyburgate

The inn was first mentioned in 1671. A meadow behind it was a venue for circuses and fairs in the nineteenth century and first half of the twentieth. The meadow was also a popular venue for quoits. In 1951 the council's Housing Tenants' Selection Committee chose tenants for the new houses on the meadow. The Black Boy closed in 1991. (Photo of inn: Frank Reed)

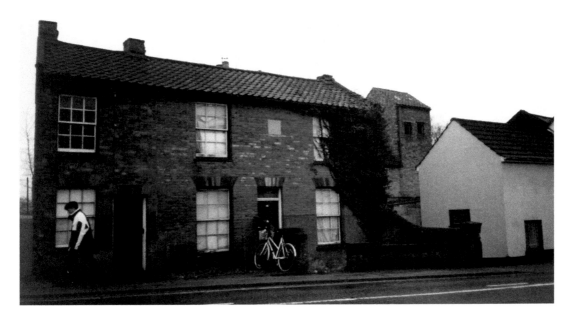

Ingate

The houses on the left were demolished and rebuilt after this photograph was taken in 1999, but the smokehouse, used by the fish curer Arthur Leggett in the early decades of the twentieth century, survives. In earlier times the stream, which now passes underneath the road and which gave its name of Anne's Bridge Street, flooded so regularly that one property was known as Noah's Ark. (Photo of 1999: Frederick Barclay)

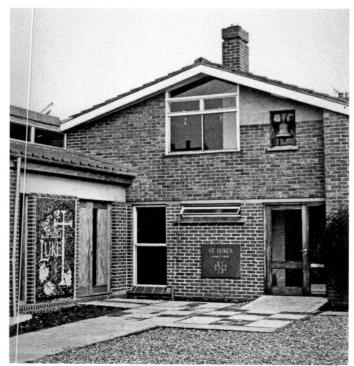

St Luke's, Rigbourne Hill
St Luke's was built to serve the housing estates of Rigbourne Hill and its vicinity, the hall being constructed in 1965 and the church in 1973. The bell came from Clowes' printing works where it had summoned employees to work. Extensive fundraising, led by John Allport, allowed the redevelopment of the building in 2007. Today Revd Rich Henderson is responsible for both St Luke's and St Michael's. (Photos: Leslie Freeman; Barry Darch)

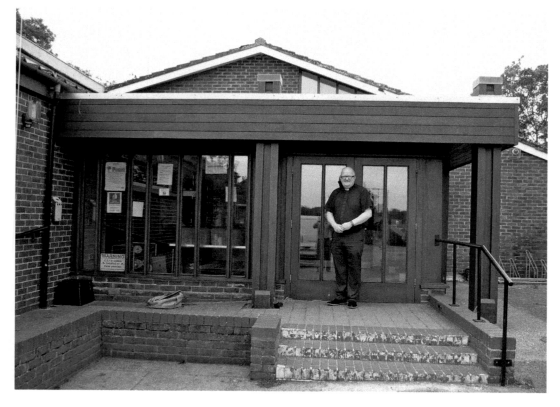

Castle Farm, *c.* 1925
Robert Sparrow, Lord of the Manor of Beccles, had the castle-like farmhouse built around 1800 to improve the view from his residence, Worlingham Park. By 1971 when the farm was sold, it had been surrounded by modern developments and before long it was demolished. It stood on what is now the corner of Banham Road and Coney Hill. (Photo: Barry Darch)

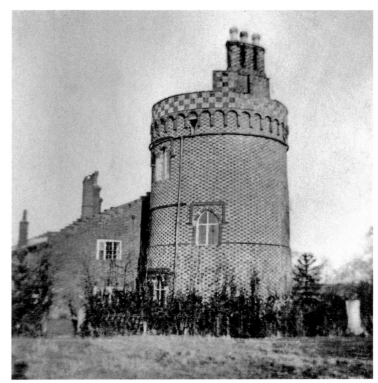

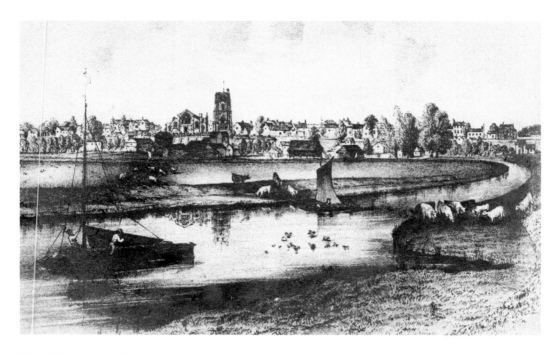

River Waveney, *c.* 1830
This postcard of 1900 used an engraving by Richard Stark first published in 1834. It shows Beccles at its best – from the river and looking tranquil. In the original the boats' sails are red rather than the characteristic black of the wherries that transported goods extensively on the Waveney up until the early twentieth century. Herring oil gave the red colour, but rats liked the flavour, so pitch was added to deter them.

Acknowledgements

Beccles has had several great collectors and interpreters of historical information, particularly S. W. Rix, more recently E. A. Goodwyn and in our own time David Lindley and Anne Frith. This book could not have been written without the dedication of the town's historians and the many people who have donated material to Beccles and District Museum. Special thanks go to Rosemary Hewlett, David Lindley, David Osborne, Michael Porter, and Roger and Rosie Tuthill for their assistance. I am grateful also to Richard Barrett, James Hartley and David Woodward for historical information and to several others who loaned photographs, answered queries or assisted in other matters. Beccles Borough Council kindly gave permission for the use of the Rix Collection. A final thank you goes to the volunteers who look after the museum's collections and who have helped me in a multitude of ways. The museum will benefit from the sales of this book.

The author and publisher thank the people and organisations who have permitted copyright material to be used in this publication. Every attempt has been made to seek permission for the use of such material, but should we have inadvertently used it without permission or acknowledgement, we apologise and will make the necessary correction at the first opportunity.